HUDSON VALLEY
CURIOSITIES

HUDSON VALLEY
CURIOSITIES

The Sinking of the Steamship *Swallow*,
the Poughkeepsie Seer, the UFOs
of the Celtic Stone Chambers and More

Allison Guertin Marchese

The
History
PRESS

Published by The History Press
Charleston, SC
www.historypress.net

Copyright © 2017 by Allison Guertin Marchese

All rights reserved

First published 2017

Manufactured in the United States

ISBN 9781467136754

Library of Congress Control Number: 2017938348

With love and gratitude, I dedicate this book to my late father, Alphé Albert John Guertin, and my grandfather Ernest Joseph Velardi Sr. My memories of them and the fascinating stories they shared with me about my own family history have been an inspiration in writing this book.

Contents

CONTENTS

Acknowledgements

I would like to acknowledge all of the people in the Hudson Valley who dedicate their time, energies and spirit to preserving our region's glorious natural and historical past. This is sometimes thankless work; therefore, I extend my sincerest gratitude and encouragement to all of you. Thank you!

I also want to thank the many individuals and organizations that have supported my work as a history writer by buying my books and inviting me to speak at your libraries, historical societies, museums, bookstores and schools. Thank you. Being with you and sharing this history has been fulfilling in ways I can't even describe.

I want to thank my fellow writers and friends who have listened, laughed and lent me their books and given me their time, advice and so much more. Lisa Lamonica, Bonnie Mackay, Jacqueline Rogers, Nancy Rothman and Lori Yarotsky lead the list, and there are so many more. Thank you.

And lastly, but never least, I want to thank my lifelong partner, my lifelong love and soon to be my lifelong husband, Adam Todd III. I wouldn't be me, and this wouldn't be a book, without you.

Introduction

Now looms the long-ago. A thrice decade
Has, somewhere, wondrous metamorphose made.
Today interprets yesterday's dark page,
As some repainted sign, half-washed by age,
Reveals the first inscription through the last,
And opens out an ever-present past.
—"The Mountaineer of the Neversink,"
a poem of four cantos by Patterson Du Bois (1847–1917)

There's something about the past that truly pulls me in. Perhaps it's because when I read and write, I see things in pictures, and I experience a book as if I'm seeing a full-length feature film running in my head. Often, when I become so engrossed in my reading and writing, I almost feel like I'm time traveling. It's as if I'm actually reliving the curious historic episodes, transported, if you will, back hundreds of years. Sometimes I'm wandering a colonial village in the 1740s or I'm standing on the deck of a sinking steamship in 1806. Why this happens, I don't know. Some people refer to it as having a "cinematic" mind. But whatever the cause, it's a thrill to revisit the people, places and events that existed in New York's Hudson Valley so long ago. Because I enjoy writing history and taking this tour of the mind, I've dedicated myself to creating books like this one so that you, too, can enjoy this fantastic journey.

It should be known that if anyone is considering writing history, you ought to prepare yourself for reading a lot of books. The research requires it. For

me, this is not a bad thing. I'm a curious person, I crave knowing new things and I'm a voracious reader.

While writing this book, I can safely say I've probably read more than fifty books, in addition to countless articles, websites, pamphlets, advertisements—you name it. Along the road to discovering the Hudson Valley's past, I've come across a few surprises.

The day I found a book written by Florence Guertin Tuttle, I was researching chapter 3, "Chappaqua's Coincidental Candidates," and looking for information about women's suffrage and presidential elections. While scanning used books on Amazon, I found her. What struck me, of course, was her name, Guertin, my family name. My curiosity was beyond piqued. I needed to know who she was. I needed to know if we were connected.

Florence Guertin Tuttle was born in Brooklyn, New York, in the year 1896. Her mother was Lucy Henry, a distant relative of Patrick Henry. Her father was Pierre Guertin, a French Canadian merchant and immigrant. In the biography I read of Florence, they described her as an avid reader and a prolific writer of poems and stories. Needless to say, as I digested our similarities, my heart raced. How very curious, I thought; my father's family was originally from Canada. I wanted to believe that Florence and I must somehow be related.

Growing up, Florence was a member of one of the first New York women's clubs, Avitas, where she listened to speakers like Charlotte Perkins Gilman, a feminist, novelist and writer of short stories.

After Florence married Frank Tuttle, she and her husband settled in Brooklyn Heights, and they had two sons. As a young mother, Florence wrote and got involved with issues like women's suffrage, birth control and the Women's Peace Party. She was horrified by the mayhem and destruction brought by World War I. In response, in 1920, she became the chair of the Women's Pro-League Council and advocated for internationalism, promoting cooperation and peace among nations. Florence wrote, "Women must create a new attitude toward war by refusing ever again to acquiesce in this evil—the desecration of motherhood and the pollution of the race at its fountain source."

I was thrilled to learn that Florence was a pacifist, a writer, an advocate and a speaker. She was vocal, literary, involved, fearless. I imagined that Florence was somewhere in my past, sharing my values and the same gene pool.

Florence went on to write many books on suffrage and women's rights. One of her most noted is called *The Awakening of Women: Suggestions from the*

Psychic Side of Feminism. I purchased a copy of the book, which is mostly out of print. I hoped that it was signed, that I would have a trace of Florence, a keepsake.

The copy was not signed, but the hunt for my connection to her is not over. I recently discovered that Florence Guertin Tuttle's papers, including family correspondence, speeches, photographs and memorabilia, are held at the Sophia Smith Collection at Smith College in Northampton, Massachusetts. This is not far from my home in Columbia County, New York. I plan to go there soon, read her personal papers, travel back in time and perhaps meet my distant relative to know her life, know her, know her past—my past, our past, our history. Happy history hunting, everyone!

PART I
LOWER HUDSON VALLEY

Putnam, Rockland and Westchester Counties

1

Strange Stone Chambers
and UFOs of Putnam

Amid the rocky Hudson Highlands in Putnam are steep slopes, granite
rock beds and sharp outcroppings. You will also find precisely positioned
loose boulders that lie around like forgotten dinosaur bones. Then, if you
venture a little farther into the deep woods, you will come across some
seriously strange structures that have become one of the Hudson Valley's
most curious archaeological mysteries.

The "chambers"—as they are known to many locals and amateur
explorers—are eerie old stone caverns built into hillsides, constructed
masterfully using immense slabs that fit perfectly together without the need
of mortar. There are roughly one hundred of these chambers in and around
towns in Putnam County, New York, and they are puzzling, really puzzling.

When looked at as simply great examples of masonry, these structures
are impressive. The chambers are not round like natural caves; they are
rectangular, with four walls and ceilings made of massive planks of solid
granite. Their stone entrances are corbelled, which means they are arched,
curved inward toward ceilings that can exceed six feet in height.

The stones used in constructing the chambers in Putnam were clearly
taken from the immediate and surrounding woods and used in their
natural form without any cutting. The chambers vary in size. The largest
is about thirty-three feet, and others are just ten feet long. Some are built
below ground.

The chambers also have front doors, and inside are odd little vent holes
running up and out of the roof. Old residents in Putnam have commented

that the chambers were nothing but perfectly built root cellars, icehouses and food storage shelters, likely made by local farmers mostly to house perishable food in summer.

Yet it appears that the stone chambers predate early European settlers, and so it seems unlikely that farmers could have built them—but that doesn't explain who did.

In a letter dated November 30, 1654, John Pynchon (the founder of Springfield, Massachusetts), the author, offered the idea that many of these stone structures, some of which were found in Connecticut, existed here long before the early colonists settled.

It reads:

> *Honored Sir, Understanding you are now at New Haven and supposing there will be opportunity from Hartford for conveyance thither, I make bold to scribble a few lines to you....Sir, I hear a report of a stone wall and strong fort (chamber) within it, made all of stone, which is newly discovered at or near Pequet (presently known as the Gungywamp Range), I should be glad to know the truth of it from your self, here being many strange reports about it.*

At the Pound Ridge Historical Museum in New York is another faded letter, dated July 1742. It is from a priest writing to a local farmer who had just discovered a stone chamber near his property in the woods. The priest instructed the man to stay away from the chamber because it was the work of the devil and a place where the devil could enter this world.

Similar chambers have been found in New York State and Connecticut, and what's more surprising is that look-alike caverns have been found in Ireland, Brittany and Portugal. There are approximately 105 astronomically aligned chambers in Massachusetts, 51 in New Hampshire, 41 in Vermont, 62 in Connecticut, 12 in Rhode Island and 4 in Maine.

At Overlook Mountain in Woodstock, New York, is a grouping of carefully constructed lithic formations that may have some connection to the chambers. When viewed together and taken as a whole, they appear to create a serpent or snake. Native Americans who have visited the site felt certain that the area and stones were ancient and quite sacred.

Depending on which rock you decide to look under, you will find that explorers have suggested varying meanings behind these fascinating antiquities. Some amateur investigators say the caves were cells for escaped slaves, and many theorize that the cavernous rooms could have been

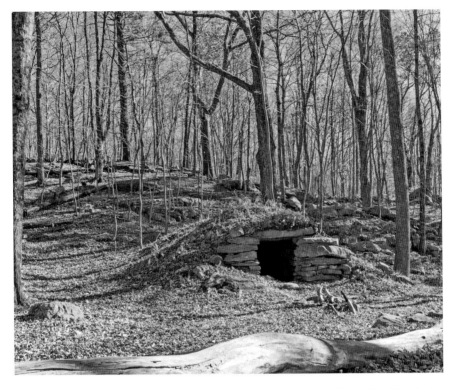

Putnam stone structures, front exterior. *Courtesy of Keltic Energy Paranormal Research and Investigation.*

mysterious time portals. Then there are a few other individuals who believe that these creepy caves are suspiciously supernatural.

Despite the varied opinions, it is obvious that the origins of the strange stone chambers go back in time, way back. Though little is known about the Putnam Valley's original inhabitants, records trace the possibility that Native Americans constructed the chambers. With fine stone carving skills, some believe that the Indians used these unusual buildings as burial chambers. There are other ideas suggesting that the chambers were designed for celestial observation associated with a native shaman's vision quests.

Another theory offers that the dwellings were perhaps built by ancient seafaring people from northern Europe or the Mediterranean, intending the chambers as burial vaults or for ceremonies. This suggests that Vikings could have built the chambers 2,500 years ago as religious observatories.

According to some scientists, these structures are not root cellars at all but ancient temples, hallowed shrines where Celtic and Phoenician seafarers

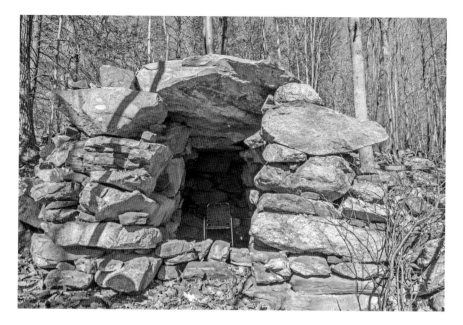

Putnam stone structure, interior. *Courtesy of Keltic Energy Paranormal Research and Investigation.*

of two thousand or more years ago would gather to offer sacrifices to the divinity of the sun. As astounding as this may seem, it is possible that the structures were used as ancient calendars, mostly lunar, designed to catch the first rays of the winter solstice and honor the rebirth of the new year.

Further research in the area shows that there has been an extensive amount of information gathered about the extraordinary power of these strange stone structures. The legend of Ninham Mountain fills the mind with real wonder.

Ninham Mountain—the highest point in Putnam County—is one place that has experts and amateur archaeologists baffled. It is located just outside Carmel, New York, and its proud peak rises over 1,600 feet above sea level.

Between 1982 and 1995, the area made world news headlines when UFOs and strange lights circling the top of the mountain were reported by hundreds of people.

Back in 1982, the aerial phenomenon was documented in the Gannett Westchester newspaper with accounts from eyewitnesses who saw unusual lights described as an enormous object shaped like a *V*. It hovered over the ground, made a disconcerting hum and gave onlookers a multicolored light

show. It wasn't small or indistinguishable; it was huge, the size of a football field. The mysterious flying craft actually stopped traffic on the Taconic (State) Parkway. A flying horseshoe is the way some drivers described it. Others preferred to liken it to a boomerang.

According to the article, the same sighting had been made about four years earlier near the towns of New Castle, Mount Kisco and Yorktown, all within the lower Hudson and Putnam Valley in the town of Kent. Additional sightings were reported in Dutchess and Orange Counties, as far south as Manhattan and as far east as Danbury and Sandy Hook, Connecticut.

At first, the authorities would have been happy to just forget about the incident—perhaps shove it under the rug—but that became impossible with the large number of people making reports. Skeptics, of course, commonly described the unidentified flying object as a plane with kaleidoscope-style lights, but investigators on the scene simply did not agree.

The sightings became so frequent that Putnam County set up a hotline. Not long after, a formal conference was arranged by a local attorney to gather the ever-increasing number of eyewitnesses who had observed the craft. By 1987, the UFO phenomenon had gathered even more steam, with a second conference attracting over one thousand believers and experts interested in comparing notes and findings.

The extraordinary events over this area of New York's Hudson Valley continued from 1982 to 1989, with a conservative estimate of over seven thousand reports of unexplained lights. The *Journal News* reported that Lieutenant Kevin Soravilla of the Yorktown Police Department was on duty on the night of March 24, 1983, when he saw a massive delta-shaped group of lights. Guards at the famous nuclear plant Indian Point have even weighed in.

Ninham Mountain, located in the town of Kent in Putnam County, plays an important role. It is where many of the chambers are located. The ancient mountain was formed about 125 million years ago, and its history is long. From the vantage point at the top, you can see all of the Hudson Valley.

Some centuries ago, strong and brave Indians of the Wappinger tribe, ancient inhabitants of the eastern shore of the Hudson River, lived close to the mountain. The supernatural site is named after Daniel Nimham, the last great chief of the Wappingers, who gave his life in defense of American independence. He is remembered as a Revolutionary hero after dying for the cause on August, 31, 1778, at the Battle of Kingsbridge. The Wappinger Indians held the mountain sacred because they believed that at the peak of the mountain was a gateway to another world.

Eastern Native Americans cultures, including the Wappingers, enacted a special ceremony there where young men braved the elements to gain physical and spiritual strength. This was known as "beseechment of the elements." Ninham Mountain was the spiritual center where many of these men experienced their spiritual journeys. It is believed that the buried remains of many Wappinger Indians are also on the mountain.

The mountain has been a recreation area for many years. Hikers who traverse the centuries-old trails say they sometimes experience a shock of energy. Others who have traveled to the top to the tower reported seeing strange mystical lights. Several books have been written on the secrets of Ninham Mountain, questioning the unexplained energy sources at the peak. To this day, the mysteries of Putnam's stone chambers and the strange night lights witnessed by so many have yet to be resolved.

2
Letchworth Village Patient Experiments

In 1919, Governor Al Smith announced in a Brooklyn newspaper that the general work had been completed for the colony at Letchworth Village, increasing the number of "inmates to be received and that this work would go on until the colony number about five thousand."

Letchworth Village was located in the hamlet of Theills, New York, in Rockland County. When built, it was New York State's most promising facility for feeble-minded people, of which it was estimated there were some thirty-three thousand roaming about New York and "of whom only about five thousand were under proper restraint."

Back in the 1900s, this "restraint" was intended not only to protect these impaired individuals from harm by putting them in a facility but also to lessen the load on charitable institutions, as well as prisons, which often housed these people. At that time, professionals strongly believed that most of the inmates being held in prisons were "below normal intellectually" and that most prostitutes and illegitimate mothers were also considered "feeble minded," according to the *Binghamton Press* of May 9, 1911. It was also common among medical professionals to believe that those with lower intellect were not fit to be parents and they were weaker and also more susceptible to disease; therefore, they were put in institutions like Letchworth for their own safety and the safety of society.

One particular account of Letchworth that was printed in 1911 stated the intention of the facility was to "segregate feeble minded and epileptics during reproductive period." The headline of the *New York Evening Post* even went

so far as to say, "Letchworth Village to End Feeble-Mindedness. 2000-Acre Institution for Cure of State's Idiots to Be Formally Opened June 1, 1911."

By the 1930s, Letchworth Village had over 3,500 people living there, most of whom were classified as mentally disabled or "retarded." Officials took pride in the village. Governor Herbert H. Lehman was fond of saying how Letchworth and other state institutions like it had become models throughout the world:

> We not only attempt to cure or improve the condition of our patients but we are seeking the means of making many of our mentally defective children an asset to the community rather than a burden by giving them mental education which, in many instances, permits them to return to their communities as self-sustaining citizens.

The model institution opened officially in 1919, with 130 buildings spreading out over 2,300 acres. The picturesque community took its architectural flavor from the famous Monticello, Thomas Jefferson's spectacular neoclassical plantation on 5,000 acres in Virginia.

Letchworth was intended to be a healthy and humane alternative to commonplace asylums and was created as a communal working farm suited for raising pigs, cows and chickens and planting enough crops to feed the entire population of residents. It was also keen on teaching the residents to make crafts and toys at Christmastime. The estimated cost when the facility was completed was over $3 million.

The Letchworth Village concept was a huge departure from the nineteenth-century almshouses, which were essentially poorhouses and had been around in Europe since the tenth century. The Letchworth farming village covered nearly four square miles. Some of the first inmates to arrive were thirty-two boys from Randall's Island, a small island in Manhattan's East River that was home to the New York House of Refuge—the first reformatory school in the United States, built in 1825.

The boys who were physically able were required to work in the garden. They were also given time in their day for swimming in the village's creek and were encouraged to understand the basics of baseball and play in a league organized by the staff doctors.

By all outward appearances, Letchworth Village was solving a very large problem by taking care of impaired and sick individuals and even supervising juvenile delinquents and people with epilepsy. Yet all of this changed when rumors of horrible patient experiments started to surface.

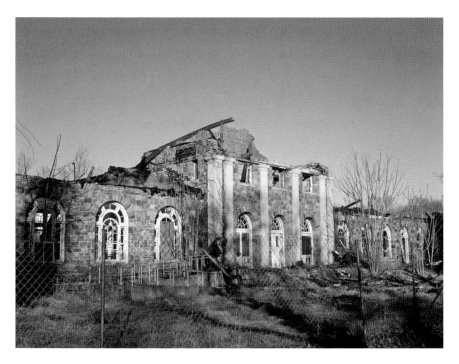

Letchworth Village ruins. *Wikimedia Commons*.

In the late 1920s, Letchworth Village administration developed a relationship with the Eugenics Record Office, which was connected to the Cold Spring Harbor Laboratory. This organization was established by Charles Davenport, a prominent biologist, who wanted to apply Mendel's controversial laws involving genetics and the hereditary factors of human beings.

The Eugenics Record Office maintained background histories of Letchworth residents and collaborated on medical experiments on children without their consent. George Jervis, a pioneer in the understanding of phenylketonuria, a genetic disease that leads to mental retardation, used the Letchworth children as his subjects, while he was the lab director.

In 1950, Dr. Hilary Koprowski, a young Polish virologist and immigrant, tested his live-virus polio vaccine on the children of Letchworth Village. Koprowski was in touch with George Jervis, who was the laboratory director at Letchworth and who had already done some important field work in the area of mental retardation. Apparently, Jervis was panicked that the children at Letchworth—whom he reported were "playing in their

filth and throwing feces around the dorm"—were like radioactive dumps waiting to blow up. He worried that the entire population of inmates could die from the rapidly spreading polio disease. At the time, Dr. Koprowski had only tried his immature vaccine on animals, but that didn't deter him. He went ahead and tried the live virus on what he called "nonhuman" subjects at Letchworth.

Neither Jervis nor Koprowski obtained consent from the children or their parents. When the first child "volunteer" received the infectious material in a glass of chocolate milk and didn't die, Koprowski administered a dose to nineteen additional helpless children, sometimes by using tubes.

No one was notified of the experiment, not even New York State officials. Many months later, the secret tests were finally revealed to a shocked scientific roundtable; participants accused Dr. Koprowski of nearly causing an epidemic, never mind breaching the ethical guidelines set forth for researchers in the Nuremberg Code of 1947 in response to Nazi medical atrocities.

Dr. Koprowski later admitted that doing such things in the modern day would certainly have landed him in prison or, at the very least, a monster lawsuit. He also said that had he not undertaken the risky testing, there would be no polio vaccine today.

William P. Letchworth, philanthropist and pioneer epileptologist, 1893. *Wikimedia Commons.*

The truth about Letchworth was that most of the patients were young. In 1921, in the village's Thirteenth Annual Report, 317 out of 506 people were between the ages of five and sixteen, with several under the age of five. Early on, there were reports of not enough food, and the children often suffered from malnutrition. The residents received no proper schooling and lived in cramped dormitories.

By the 1950s, when the polio tests took place, Letchworth had reached a staggering four thousand inmates. In the 1940s, news photographer Irving Haberman released a series of photographs he took at Letchworth revealing the cruel conditions and dirty, neglected patients being used as workers. The photos appeared in Albert Deutsch's volume *The Shame of the States,* a

harsh critique of mental hospitals. It wasn't until the 1970s, however, when the ABC News Network aired a special report on the conditions of state-run mental hospitals, including Letchworth, that the issues at the facility were truly seen. Amazingly, little was done.

Letchworth Village finally closed for good in 1996. The true irony is that the village was named for William Pryor Letchworth, a noted humanitarian and philanthropist who was deeply concerned with institutional conditions.

Today, Letchworth Village is a mass of abandoned crumbling stone buildings with overgrown lawns and terrible memories for the townspeople who recall the institution's strange history. The suffering of the deceased patients, some say, is still felt in the broken walls by those who dare to visit the decaying old asylum. The most haunting aspects of the abandoned institution are the unmarked graves hidden deep in the woods in a forgotten cemetery. A football-length field reveals a few meager headstones and a vast collection of simple *T* markers bearing only numbers—no names.

3

Chappaqua's Coincidental Candidates

Presidential candidate Hillary Clinton and former president Bill Clinton bought a house in Chappaqua, New York, in the late 1990s that sits about a half mile from Horace Greeley High School. The school is named for another one-time presidential candidate, Horace Greeley, and former Chappaqua resident. Clinton lost the 2016 election after a heroic effort, and Greeley lost the 1872 presidential election not only to Ulysses S. Grant but also another candidate—a woman, in fact—whose name often gets lost in our history.

In 1872, Horace Greeley also ran for president against Victoria Woodhull, a woman running on the Equal Rights ticket. Victoria holds the distinction of being the very first woman ever nominated to run for president of the United States. Curiously, Hillary Clinton was the first woman ever to be nominated as a major party's candidate. What are the odds that Greeley and Clinton would end up in the same Hudson Valley town? Perhaps Victoria Woodhull's unusual powers had something to do with creating this coincidence.

Victoria Claflin Woodhull, a blue-eyed beauty, was born in 1838 in Homer, Ohio. Her father, Buck Claflin, was a one-eyed con man, a thief who was often violent with his children and his wife, Roxy, an illiterate religious fanatic. In Homer, Woodhull's family was known as town trash. Ten children and two parents all crowded into an old shack on the edge of town. The space was cramped, and food was scarce. Neighbors feared Roxy and called her a witch. What saved Victoria, perhaps, were the otherworldly

Horace Greeley, 1917. *Library of Congress.*

entities she claimed as her protectors and guides. The details of her spirit story are documented in a biography written by Theodore Tilton in 1871.

Tilton wrote that one of her visitors was called "Josephine" and the other "Napoleon." The third, which identified himself as "Demosthenes," appeared to her wearing a Greek turban and leather sandals. She called him her "majestic guardian," and he visited her almost daily throughout her entire life.

Victoria was grateful for the spirit guides. She knew had they not come down from some unknown realm, she might have died at the hands of her abusive father, a thief known for stealing horses and taking packages out of the U.S. Post Office.

Though she suffered intensely, somehow Victoria believed that miraculous things could happen, and her three guides steered her in that positive direction. She always felt that her destiny was reflected in her name, which implied victory. It's interesting to note that the name "Hillary" translates from Greek as "cheerful and prosperous."

With help from her spirit guides, Victoria emerged from poverty and rose to achieve both wealth and fame. In the 1800s, girls didn't always go to school, yet she educated herself and developed her strong sixth sense, which gave her the ability to communicate silently with her little sister Tennessee "Tennie." Her extrasensory perception also allowed her to predict events, locate objects that were at a great distance and read the thoughts of others.

Hoping to escape Homer, Ohio, and her parents, when she was just fourteen, Victoria married a physician, Canning Woodhull. It would be the first of her three marriages. Her new husband, sadly, was a drunk and a cheat, and she barely escaped him with her son, Byron, who was born with a mental disability.

Setting off on her own, Victoria launched a business as a spiritualist healer, using her unusual powers and the influence of her spirit guides to cure deaf people and mend broken limbs. The news of her success spread rapidly

throughout Ohio, and even police and lawyers engaged her clairvoyant services to solve crimes. Moving her healing practice from city to city, she became a wealthy woman.

By the late 1860s, the Civil War was raging and Victoria had left Canning Woodhull and married Colonel Blood, a war veteran. By this time, her supernatural powers were even stronger, and Blood helped advance her popularity and visibility in politics.

Much like Hillary Clinton, Victoria Woodhull broke a few glass ceilings. Late in 1868, after Lincoln was assassinated, Victoria received a message from her spirit friends to go to New York City. It was there that she and her sister Tennie launched the first female brokerage firm, Woodhull & Claflin, on Jones Street in 1870. Because women stock traders were unheard of at this time, the business became a kind of circus side show with thousands of people arriving to get a good look at the lady brokers.

To further their business status and express her political views, Victoria started publishing the very first woman-owned newspaper with Tennie: the *Woodhull & Claflin Weekly*. Printed on the front cover, beneath the five-cent paper's name, was, "Progress! Free Thought! Untrammeled Lives!" And then, in smaller print, followed a promise: "Breaking the Way for Future Generations."

At the time, Horace Greeley was the founder and editor of the *New York Tribune* newspaper, and Victoria owned a competing paper. Little did they know that later on they would also compete for the presidency of the United States.

Victoria's rising success in the stock market, as a publisher and as a true spirit communicator brought great admiration, but many still made a sport out of publicly criticizing her. The condemnation came not only from men but also from women (a dilemma also shared by Hillary). And then there were the newspapers in which Victoria was a favorite subject of gossip, suspicion and speculation. The harsh and painful words might have stopped a weaker woman, but not Victoria. In retaliation, perhaps, she took control of the editorial in her newspaper, publishing article after article supporting free love, abolition of the death penalty, short skirts, vegetarianism, excess-profit taxes, spiritualism, world government, better public housing, birth control, magnetic healing and easier divorce laws.

In one well-publicized scandal in the *New York Sun*, Victoria appeared on the street in New York in "knee-length pants, blue stockings, tunic and necktie," violating laws in the late 1800s that forbade women from wearing such clothing in public.

In a time when women everywhere were talking about equal rights, Victoria took a strong position on securing a woman's right to vote. In another first, she accepted an invitation to testify before the House Judiciary Committee to air her views on women's suffrage.

On January 11, 1871, wearing a necktie and an Alpine-style hat that matched her expensive dark blue dress, Victoria arrived in Washington. The timing of her speech corresponded to the Washington meeting of the National Woman Suffrage Association led by Susan B. Anthony, Isabella Beecher Hooker, Elizabeth Cady Stanton and Paulina Wright Davis, taking place that same morning.

A huge crowd gathered, including suffragettes from the nearby convention, to hear Victoria defend her argument that, according to the Constitution of the United States, women had the right to vote. It was the very first public speech of her life, a moment that her spirit guides had put in motion. She took no time before blasting the members of the committee with her theory. Her argument made sense. She said,

> *The sovereign will of the people is express in our Constitution, which is the supreme law of the land. The Constitution makes no distinction of sex. The Constitution defines a woman born or naturalized in the United States, and subject to the jurisdiction thereof, to be a citizen. It recognizes the right of a citizen to vote....*
>
> *Therefore, your memorialist would most respectfully petition your Honorable Bodies to make such laws as in the wisdom of Congress shall be necessary and proper for carrying into execution the right vested by the Constitution in the Citizens of the United States to vote, without regard to sex.*

It was an astonishing moment, and Victoria had earned respect from the committee with her frankness without giving up her dignity. The motion, however, was denied by a majority of the Judiciary Committee, but Victoria made history by obtaining a minority report in favor of it. The report was signed jointly by General Benjamin F. Butler of Massachusetts and Judge Loughridge of Iowa.

Many would call Victoria Woodhull the Joan of Arc of the women's movement. Her biographer Tilton wrote, "Victoria Woodhull fought the folkways that pressed her sex, as audaciously, as courageously as the Maid of Orleans fought the entries of France."

In her most famous moment, on May 10, 1872, Victoria gave a speech supporting her cause at the Apollo Hall in New York City, where the

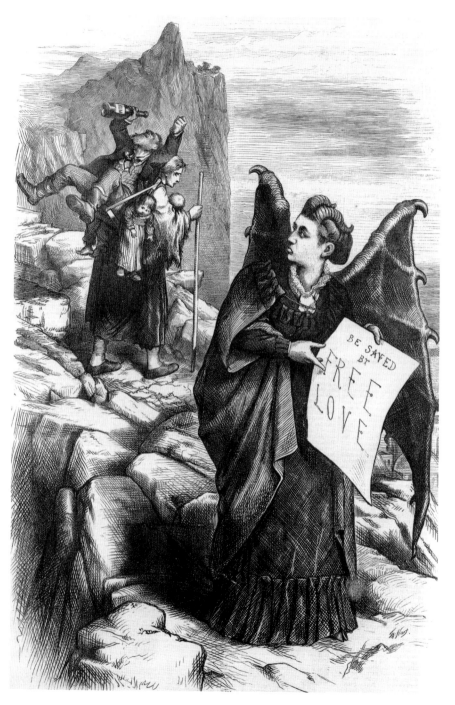

A sketch of Victoria Woodhull as Mrs. Satan in *Harper's Weekly*. *Library of Congress.*

National Woman Suffrage Association was holding its annual convention. Members of the NWSA formed an offshoot of the People's Party, which was newly named the Equal Rights Party. In the evening, Victoria was called to make her speech on "Political, Social, Industrial and Educational Equality." At the end of her delivery, the crowd swarmed her, cheering, hugging and kissing her. Just as she was about to leave the stage, Judge Carter of Kentucky bolted from the audience, jumped up onto the stage and said, "I believe that in what I am about to say I shall receive the hearty concurrence of every member of this convention. I therefore nominate for President as the choice of the Equal Rights Party of the United States, Victoria C. Woodhull."

Despite her achievement and her bravery, her critics called her "Mrs. Satan" and, later, "The Prostitute Who Ran for President."

What's also amazing is that Victoria Woodhull did this almost fifty years before the ratification of the Nineteenth Amendment in 1920, which gave women the right to vote. On Election Day, November 5, 1872, Victoria Woodhull couldn't even vote for herself.

Like Hillary Clinton, she positioned herself against the tough incumbent, Republican Ulysses S. Grant, and Democrat Horace Greeley, who was running under the Liberal Republican Party. To add another layer of complication, she selected as her running mate Frederick Douglass, a former slave turned abolitionist writer and speaker, though he never acknowledged the nomination.

Victoria Woodhull's candidacy never took flight, and she lost the election—but so did Horace Greeley. And though she continued to speak out on women's suffrage, her name is often omitted from this history.

By 1883, her newspaper had closed and so had her brokerage firm. Under financial strain, she moved her family to London, where she married an English banker. In 1884 and again in 1892, Victoria tried without success to run again for the presidency. She died in London in 1927 without having fulfilled her dream of becoming president.

History notes that Horace Greeley actually turned out to be the biggest loser in the 1872 election. When the nation voted on November 5, 1872, Grant obliterated Greeley, gaining 286 electoral votes to Greeley's 66, carrying thirty-one states. Amazingly, Greeley did not even carry his home state of New York. After the crushing defeat, Greeley retreated from public life, and some say he became rather mentally unstable. Strangely, Greeley died soon after on November 28, 1872, even before the electoral votes of the famous presidential election had actually been counted.

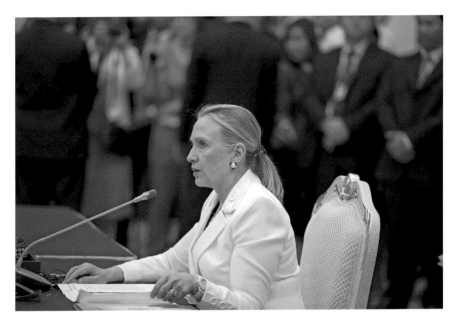

Secretary Hillary Clinton making remarks to the UN. *Library of Congress.*

Until Hillary Clinton moved in, Greeley had perhaps been Chappaqua's most famous resident. In 1835, he bought a farm in the town where he and his family spent weekends until he died.

In 1998, the *New York Times* reported that his home was to be split up into luxury apartments before the local historians received ownership of it. The Greeley farm is now preserved. One can only speculate what will become of the Clintons' home if ever they should vacate their residence. And will the next school be named for Hillary? Time will tell.

4

West Point's Great Chain and the Girl Who Went to War

When the Englishman Henry Hudson sailed up the big, wide North River in September 1609, passing New York Harbor, he twisted northward and rounded a point of land and anchored there. The waterway, which is technically a fjord, an estuary, would later bear his name, and the area would be known as West Point.

During the Revolutionary War, when the British wanted control of the American colonies, this spot, West Point, would become critical in the protection of all of New England.

It seems logical that during the Revolution, those fighting on the American side would try to find a way to block enemy ships from traveling up the Hudson River. In 1778, it was decided that the best way to stop the British from making a second attack at Kingston and Albany was to build a monstrous metal chain and place it across the narrowest place in the river. The real question was how.

It was calculated that even at the best possible location, to cover the expanse, the chain would have to be 1,700 feet long, nearly a mile in length. "Chaining" the river meant stringing 1,200 extremely heavy iron links, weighing nearly 186 tons, over the water. A single link could be as heavy as one man. General George Washington believed that holding the river was the key to winning the Revolutionary War, so despite the daunting task, the chain was absolutely essential. Captain Thomas Machin, an artillery officer, was ordered to handle the project even though he had no formal training as an engineer.

Building the chain required six men hammering day and night at seven separate forges to make the lengthy metal barrier within a six-week timeframe. The cost of the Great Chain was an astonishing $400,000.

Making the chain was only half the battle. Putting the chain in place required buoying it up with heavy sixteen-foot-long logs. The logs were placed in the river at short distances from one another and the chain carried over them. Anchors were dropped in the water at the proper distances with cables fastened to the chain to give it stability. Once in place, the chain made West Point the strongest post in America.

It was reported that when Benedict Arnold was plotting the surrender of West Point to the British in 1780, he wrote to Major John André, "I have ordered that a link be removed from the great chain and taken to the smith for repair." The chain, however, remained in place until the end of the war.

But the story has an even more curious side. The first discovery of iron ore in the American colonies was made at Sterling Mountain in the town of Monroe, New York, in 1750 by Cornelius Board, an immigrant from Sussex, England.

A charcoal blast furnace was built at Sterling Pond to manufacture anchors. The Great Chain's iron was wrought from ore from the Sterling Iron Works, which began in 1761 and continued to operate until 1842.

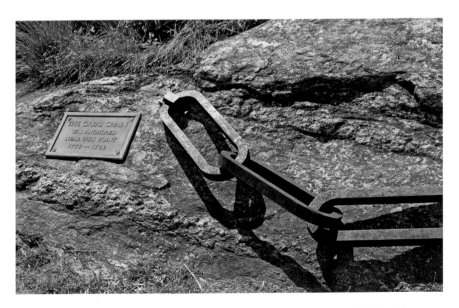

Great Chain historical marker at Trophy Point at West Point, New York. *Wikimedia Commons.*

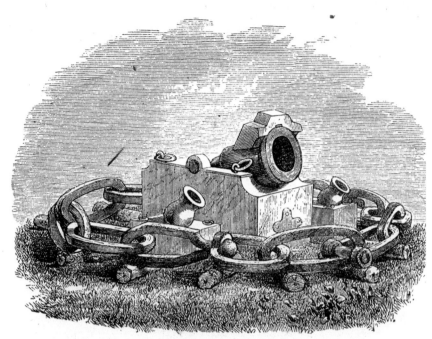

THE GREAT CHAIN.

Great Chain etching, *Harper's Encyclopedia*, 1905. *Wikimedia Commons.*

The chain was manufactured at Board's Sterling Iron Works about twenty-five miles (forty kilometers) from West Point. Sterling Iron was named for American general William Alexander, also known as Lord Stirling, who was owner of the mine's land and, later, an officer in the Revolutionary army. Sterling Iron Works was later owned by Peter Townsend. Townsend made anchors, and his son, Peter Jr., continued his work in 1810. The first cannons made in the United States were cast at Sterling for the government in 1816.

The Townsend family has further links to the Great Chain story related to the discovery of Benedict Arnold. It seems that Peter Townsend's cousin Sally Townsend had a brother, Robert, who was a member of General George Washington's famous Culper Spy Ring. The task of the ring was to inform General Washington as to the activities of the British army in New York City, the base of their operations. Robert (who used the alias of Samuel Culper Sr.) allegedly intercepted a message from Arnold at the family home in Oyster Bay, Long Island, occupied by British soldiers. Arnold wrote in his note that he had weakened the Great Chain, and he gave instructions as

to how the Royal Navy could breach the Americans' defenses and take the fort at West Point. When Arnold realized that he had been discovered, he escaped to the British, and the chain remained intact.

Ultimately, the Great Chain did its job and prevented the British naval vessels from advancing.

Today, sixteen links are preserved at the United States Military Academy, established at West Point in Orange County in 1802, as a memorial to the industry and ingenuity that kept the famous Hudson River free. The memorial is positioned at Trophy Point on the military school campus, where there is a magnificent view of the Hudson River.

While the Great Chain might have put an end to the British's chances of reaching Albany, it did not put to rest the continuing curiosities about West Point.

The mysterious military academy hides a few more secrets, including the story of Patriot Deborah Sampson, the girl who went to war. Her strange story ties her to the Hudson Valley with a unique connection to Westchester County.

Deborah Sampson was born in Plympton, near Plymouth, Massachusetts, and descended from the Pilgrims who came over on the *Mayflower*. After her father deserted her mother and her six siblings, she was sent to live with her cousin, a Miss Fuller, at age five. While living with Miss Fuller, she was taught to read and write, but when Miss Fuller died three years later, Deborah was sent to care for an elderly widow woman as a servant.

At age ten, she lived on the farm of Deacon Benjamin Thomas and his wife and twelve children. She, like all other girls, was denied the opportunity to go to school, but she learned to weave and spin, as well as taking on chores like chopping wood. To further her education, she stole books from the boys in the household. Her studies advanced her in such a way that by 1779, she was teaching school during the summer sessions.

Deborah did not think that the girls should be instructed mainly in knitting and sewing; in her classroom, the girls received the same education as the boys. When she turned twenty-one, her mother insisted that her daughter be married and went on a mission to find her a proper husband so that she could settle down and become a model wife. Deborah did not agree. She found the man that her mother had selected to be boring, and she had no intention of spending the duration of her life in the sleepy New England town. She didn't want to marry, and after following the horrors of the Revolutionary War, she wanted to help. Deborah longed to travel and see the country, something that she could never do as a lone woman with no money. She said,

In fact shall I swerve from my sex's sphere for the sake of acquiring a little useful acquisition; or, shall I submit (without reluctance, I cannot) to a prison; where I must drag out the remainder of my existence in ignorance; where the thoughts of my too cloistered situation must forever harass my bosom with listless pursuits, tasteless enjoyments, and responsive discontent?

The situation, she knew, would require cleverness and ingenuity. In the fall of 1780, Deborah used her homemaking skills to spin and weave fabric into a man's suit, which she took to a tailor in a distant town, explaining that the clothes were intended for a relative of hers who was about her size. She plotted to disguise herself as a man and join the army. Slim and tall, nearly five feet, seven inches in height, Deborah believed she could pass for a young man of eighteen. As an experiment, she borrowed the clothing of a neighbor boy and went into town to see if she could walk around without being detected. The first time, she went at night and entered a local tavern, where she drank with a boisterous group of young men. Empowered by her success, she made another trip into town dressed in men's clothing—this time in broad daylight. Soon after, she presented herself at an Uxbridge, Massachusetts recruiting station in May 1782 and enlisted under the fictitious name of Robert Shurtlieff (Shirtliff).

Her regiment was sent to West Point. During a battle, her head was grazed by a knife, but she recovered quickly. In October, she and her fellow soldiers were cold, tired and hungry. She and a few others fell upon a smokehouse belonging to the Loyalists in the woods. Her commander ordered her to return to the smokehouse at night, cut down as many hams as she could and then set fire to the building. Deborah accepted her assignment, and she and eleven other men snuck back to the storehouse that night. With a small knife, Deborah cut down four hams and handed them over to her companions before they were spotted. She torched the building successfully, but as she was fleeing, a sharp pain erupted in her right leg. She had been hit by gunfire. Two soldiers carried her to the hospital, where a doctor insisted he immediately pull the bullet out of her body. Deborah asked if she could rest first and, when she was alone, crawled out of her bed and dragged herself to a nearby cave. Once inside, she lit a fire, prepared her knife and proceeded to carve the first bullet out of herself. She never was able to extract the second bullet but returned to West Point a few days later.

When the war ended in 1783, she was sent to Philadelphia, where she became very ill and fell unconscious. At first, doctors thought she was dead,

but when she was examined by a Dr. Binney, he revealed that Robert Shirtliff was alive and very much a woman.

Paul Revere wrote a letter to William Eustis, a member of Congress from Massachusetts, in support of a military pension for Deborah Sampson (Gannett), who served in the Continental army for seventeen months during the American Revolution disguised as a man. Further records mention that she was given an honorable discharge by General Knox Pension Office records. She was reportedly personally discharged by Washington. Later, Washington invited Deborah to visit him at the capitol and gave her a pension and lands for her services.

When she was returning to West Point to receive her discharge papers, her boat capsized on the Hudson, and her diary and other personal possessions were swept away by the river. Despite this loss, Deborah's story and her accomplishments live on.

5

The Leather Man Tramp

The Leather Man was a strange tramp, a vagabond. He was known by many residents who lived in and around Peekskill, New York, and eastern Connecticut, where he was often spotted roaming the land. He wandered around the countryside between the lower Hudson Valley and the Housatonic River for about forty years in the late 1850s and became the source of colorful stories told year after year, making the Leather Man a real-life legend.

According to Orville F. Ireland, who collected newspaper clippings of the old man's journeys, "He was a curiosity as he passed over his regular route once a month for fifteen or twenty years."

Other reports and eyewitnesses said that the Leather Man dressed entirely in leather, "from the crown of his head to the sole of his foot." He had a leather coat, pants and hat. His clothes weighed about thirty pounds, and he wore them winter and summer. On his face he sported a "grizzled beard."

His leather outfit, it seems, was entirely hand-sewn by him using scraps and bits of leather donated by the people he would visit. Rumors circulated that he never wore underclothing of any kind, though kind people tried but failed to have him consider some type of flannel garment in the winter to protect him from severe cold. People were very generous toward him, buying him cowhide boots, which he refused to put on his feet. He carved them up, taking off the tops and leaving just the soles.

The Leather Man was indeed a true wanderer. He carried a leather bag and collected cigarette butts along the roadside. To balance himself, he used a cane, which he carried in his right hand, and he walked staring down at the path rather than looking up to see where he was going.

As many homeless people tend to do, the Leather Man lived outdoors most of the time. Sometimes, he made his home in a cave in the Saw Mill Woods near Shrub Oak, a hamlet just outside of Yorktown, New York. Those who spotted him said he would take refuge in the cave just long enough to "oil his clothing" and make other necessary preparations needed for his next journey.

There in the cave he had a few necessities like a tin pail, a frying pan and a small axe. To stay warm, he would make fires out of dried leaves. Alongside his household items were some shoemaker's tools used for cobbling. His caves were said to have also been found on Turkey Mountain, in the southern part of Yorktown, as well as one near Croton Falls and one near Woodbury, Connecticut.

In the *Port Chester Journal* newspaper in 1885, the Leather Man was erroneously reported to be dead—apparently frozen to death. The reports were proven to be untrue. For some strange reason, newspapers in both Connecticut and New York continued to report his disappearances and appearances. Here and there he would show up and cross paths with townspeople, hunters and children whom he unintentionally frightened.

The Leather Man survived entirely through goodwill gestures and collecting handouts as he tramped all over the region, making regular stops despite heavy snowfall and very bad weather. But the Leather Man's life wasn't always so desperate.

It seems that the eccentric wanderer was born on the rural outskirts of Paris around 1839. Though he was a poor child growing up, he attended school and then college in Paris. It was there that he met the daughter of a wealthy leather merchant and fell passionately in love. When he left college, he asked this girl's father for her hand in marriage but was refused.

The father said that his daughter deserved a man who could provide her with a grand home and the many luxuries she had grown accustomed to. But that was not the end of it. The Leather Man persevered. Instead of turning him away, the girl's father took him in as a partner, promising that he could have his daughter in marriage if he became successful in business.

The plan was set in motion and all was running smoothly enough until one day when he decided to buy an immense order of leather without first

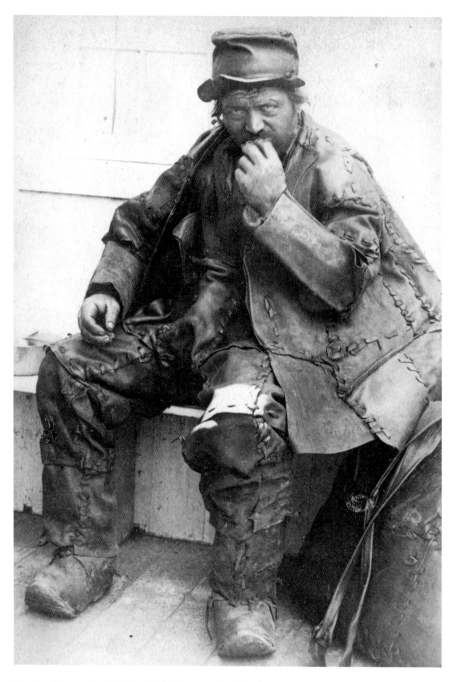

Leather Man eating, Wallingford. Photographed by George W. Bartholomew sometime before 1889. *Courtesy of the Connecticut Historical Society.*

asking his boss's permission. Because of his error, the Leather Man was banished from the merchant's house forever, and he would never see his true love again.

The loss of his career and his beloved young lady apparently drove the Leather Man mad. His condition was so grave that he was forced to enter an insane asylum. When the Leather Man was released, he went directly to Paris to see the beautiful young lady he loved so much. Yet when he arrived, he found out that she had died—some say from a broken heart.

By then, both of the Leather Man's parents had also died, and he found himself very much alone in the world, without friends or a means to support himself. It was at this point that he voyaged to America, where he simply wandered. Under his coat, he carried a French prayer book given to him by his mother. Inside the book was said to be a photo of his dear young lady, looking away from the camera, crying.

He wandered the roads of the Hudson Valley, appearing suddenly at the door of a farmer's kitchen in a homemade leather suit. He did not ask for funds but accepted bits of food or a meal. He kept his routes quite regular and covered an extensive territory. An estimate of one extraordinary loop covered nearly 365 miles and took him over a month to do, including about 240 miles through Connecticut and 125 miles through New York. He was so precise on his schedule that when he didn't arrive in a particular town on a particular day, residents became concerned, and the newspapers speculated that he had perhaps been killed or frozen to death.

When greeted or spoken to, the Leather Man always pretended that he didn't understand the English language. Often he mumbled or grunted a few words. There was one incident reported in Trumbull when he met up with a young lady traveling in a sleigh and asked her—in very good English—her destination and the contents of her sleigh.

Some believed that the Leather Man might have been of French Canadian descent with possible Native American ancestry, which accounts for his ability to speak both French and English and would give him the knowledge to live off the land, helping him survive in the woods on herbs, fruits, nuts and edible plants.

In 1889, after traveling through the states of New York and Connecticut since 1857, nearly thirty-two years, the Leather Man finally succumbed to the elements. The Leather Man had somehow survived the blizzard of 1888, but at the end of the winter of 1889, he was found dead in his cave dwelling on the Dell farm in Briarcliff. A correspondent of the *Norwalk Hour* reported that the last time he was seen in that area, cancer had eaten away the better

part of his lower jaw. It was discovered that his name was Jules Bourgeon (sometimes spelled Bourglay) and he was indeed born in France. After he was removed from his cave, his leather clothing was taken and weighed. The pieces weighed nearly sixty pounds.

AUTHOR'S NOTE

Just as a strange coincidence, I discovered while researching the old Leather Man that just before his death in 1888, he visited the town where I grew up, North Haven, Connecticut.

Cold and tired and standing in a freezing rain, a kind family took the Leather Man in and fed him home-cooked cakes and bread and hot milk. The Barnard family, who were so charitable to the old tramp, lived on Maple Avenue, not far from my childhood home. Although he declined to talk while in the company of Mr. and Mrs. Barnard, he simply pointed to the road when he finished his meal. That was the last they saw of him.

6

Outrageous Octagonal Houses

The best way to start this story is perhaps with a quick look at the history of the eight-sided home. A fair number of octagonal houses were erected between the years 1849 and 1861, and before the Civil War, there were about sixty-nine octagonal houses in the United States, some of which have been included in the National Register of Historic Places.

Oddly enough, there were once 120 octagonal houses in New York State, with some of the most astounding examples sprinkled throughout the Hudson Valley. What's more curious is the fact that the most famous octagonal house, the only domed home of its kind (still existing)—the Armour-Stiner House, also known as the Carmer Octagon House—is in Irivington, New York, in Westchester County.

Around 1859, Paul J. Armour had this special house built on a majestic hill overlooking the Hudson River using plans inspired by Orson Squire Fowler. The dome, however, was added later by Joseph Stiner. For thirty years, from 1946 to 1976, the extraordinary home was occupied by a historian who said that the residence was haunted. Carl Carmer wrote about the haunting in a book published in 1956.

Much of the inspiration for all of the homes came from one man, Orson Squire Fowler (1809–1887), a phrenologist and the leading creator of the octagonal houses.

Orson Fowler lived in western New York in a town called Cohocton. As a young man of just seventeen, he left home on foot for Massachusetts. With just a few dollars in his pocket, Fowler reportedly walked nearly four

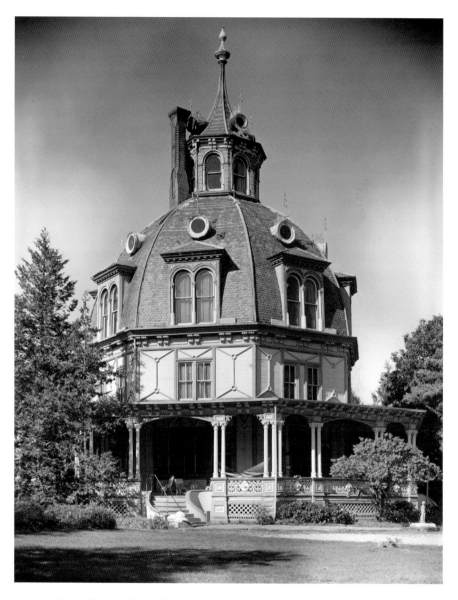

Armour-Stiner House. *Library of Congress.*

hundred miles so that he could be tutored by two Congregational ministers before enrolling in Amherst College in 1829.

Fowler was determined to become a minister, and he was equally motived to pursue a new science called phrenology with his friend Henry Ward Beecher. Phrenology is a theory that states one can determine a person's

character and personality traits simply by the shape of his head and that reading the bumps, ridges, hills and valleys on a person's skull can reveal the individual's mental faculties. The concept was discovered and promoted first in 1800 by a German physician named Franz Joseph Gall (1758–1828). The word itself is made up of two Greek words: *phren*, meaning "mind," and *logos*, meaning "knowledge."

Gall believed that the contours of one's cranium revealed inherent traits. He offered that where a trait was foremost, a person's skull bulged at the precise spot. Just by touch or feel, a trained phrenologist could discern the bump of knowledge, the bump of artistry and so on. Some theorize that this peculiar science dates all the way back to Aristotle. Oddly enough, one of the earliest known octagonal structures is the *Tower of Winds*, built in 100–50 BCE, in Athens, Greece.

After listening to a lecture in Boston given by Dr. Spurzheim of Austria and graduating from Amherst College, Fowler and his friend Beecher gave up their goal of becoming ministers, preferring to travel around the United States, preaching not the word of God but of the good works of their new science of phrenology. They believed so strongly in this new and alternative medicine that they set off to tell the world. Along the way, they made quite a bit of money by charging people two cents a head for a reading. To best serve their customers—and refine their practice of the new science—Fowler and his friend followed the path of other phrenologists who literally drew a map of the brain.

In 1835, Fowler had the idea of building a museum to showcase his work as a phrenologist. He went to New York City and opened his museum at Clinton Hall. The museum was no more than two long store fronts featuring cases filled with books, counters and desks and a strange phrenological cabinet containing the skulls and busts of some of the most distinguished men who ever lived. Besides these curious collectibles, there were over one thousand skulls of human beings and animals from all over the world, including those of Egyptian mummies, robbers, pirates, murderers and thieves. In the rear of the museum, Fowler had an office where he examined the heads of such famous people as James Russell Lowell, Samuel F.B. Morse, Cyrus Field, Lucretia Mott, Phineas T. Barnum, John Charles Fremont, Jenny Lind, Edgar Allan Poe, Elisha Kent Kane and even the head of a baboon named Miss Fanny. By reading the heads of celebrated people like President James Garfield, Brigham Young of Mormon fame, Ralph Waldo Emerson, Mark Twain, Walt Whitman and John Brown, he became somewhat of a celebrity.

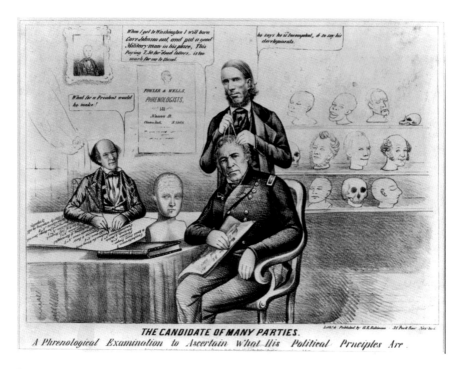

Phrenological exam. *Library of Congress.*

Beyond building his museum of oddities, Fowler went on to author and publish more than a dozen books. When he took on a partner, his brother-in-law, Samuel Wells, they established a firm known as Fowler & Wells. It wasn't long before the business became a leading publisher in the fields of phrenology, water cures, mesmerism, psychology, phonography (describing speech with symbols) and other health and hygiene movements of the nineteenth century.

In 1849, the partners sold 200,000 copies of their phrenological almanac at six cents a copy. They also made phrenological busts, which they sold for a dollar each. These busts were carefully labeled and numbered and became a teaching tool for students of phrenology.

Despite the resounding success, not everyone gave the pseudoscience of phrenology high marks. The writer, historian and illustrator Benson J. Lossing printed a rather punishing article ridiculing what he called "bumpology" in the March 26, 1836 issue of his paper, the *Poughkeepsie Casket*. Lossing signed his article "Timothy Wiseacre, Professor of Sapology."

It's likely that Lossing could have attended a phrenology lecture in Poughkeepsie as early as 1835. There were many advertisements in the

Poughkeepsie newspapers in the late 1830s, '40s and '50s describing lectures on phrenology given by Orson Fowler.

No one is exactly sure why Fowler drew a direct line between his fascination with the contours of a person's skull to the building of an eight-sided house, but it is clear that he believed strongly that there was a significant link between the obscure shape of a human head and the shape of house. One theory states that the idea came to him during a trip to lecture at Milton College in Wisconsin. Joseph Goodrich, the founder of the academy, built himself an unusual six-sided house known as Goodrich's Folly. The odd-looking house was made of cement, small stones and sand. It appears—right then and there—Fowler gave up phrenology and took up architecture.

Another theory floats the idea that Fowler felt that the octagonal shape of a home was healthier and perhaps the perfect building form for a dwelling. In 1848, he published *A Home for All, or a New, Cheap, Convenient and Superior Mode of Building*. In the book, he explained that the octagonal house was best because it was less expensive to build, could be made smaller or larger—serving the needs of families with wealth and those without—and that an eight-sided house allowed far more sunlight, promoted better air circulation, used less heat in the winter and wasted less space in hallways. Fowler wrote that "beauty and utility were inseparable."

Decades before Fowler's book was published, another architectural pioneer, Thomas Jefferson, began building Poplar Forest, his plantation-style octagonal retreat in Virginia. The eight-sided brick structure featured such innovations as skylights and an indoor privy. George Washington also dabbled in these innovative architectural buildings when, in 1792, he had a sixteen-sided grain-threshing barn constructed on his Dogue Run Farm near Mount Vernon, the famous Virginia estate.

To prove his theories about houses, Fowler began constructing Fowler's Folly in 1843, a mammoth five-story octagonal home on 130 pristine acres along the Hudson River near Fishkill, New York. The house was to be built around a spectacular seventy-foot spiral staircase running from the basement entrance all the way to a glass cupola at the top. The home would boast sixty main rooms and forty other miscellaneous rooms and closets. The main floor had four octagonal rooms that could be opened up to make one enormous room by folding back moveable partitions. In its subdivided state, it contained a parlor, a sitting room, a dining room and an "amusement" room. When the four rooms were combined, there was nine hundred square feet of floor space available.

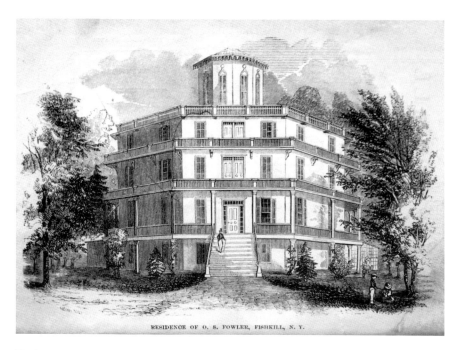

RESIDENCE OF O. S. FOWLER, FISHKILL, N. Y.

Fowler octagonal mansion. *Wikimedia Commons.*

The home had innovative features like central heating, indoor flush toilets, a roof cistern to collect rainwater, natural gas lighting and "speaking tubes" (early intercom systems) connecting the rooms, as well as a water filtration system. The home had dumbwaiters carrying food from floor to floor and several food storage rooms in the basement. The house was also built with a new form of construction that Fowler had discovered in Wisconsin, with the exterior walls being made of a mixture of lime, gravel and sand—in other words, the walls were made of an early form of concrete, giving builders a glimpse into the future. Fowler's Folly was constructed between the years 1847 and 1856. Ironically, he didn't live in the house long, and evidently, neither could anyone else. The magnificent home stood empty until it was torn down in 1900. Fowler eventually retired to his farm in Sharon, Connecticut, where he died in 1887.

Hundreds of octagonal houses were built in New York, New England, Wisconsin and elsewhere from the 1850s until the start of the Civil War, when the trend faded. Today, several examples of the octagonal house are still standing.

In Columbiaville, New York, just outside of Hudson, is John Smith Octagon. Built in 1860, the home has gravel wall construction, as suggested

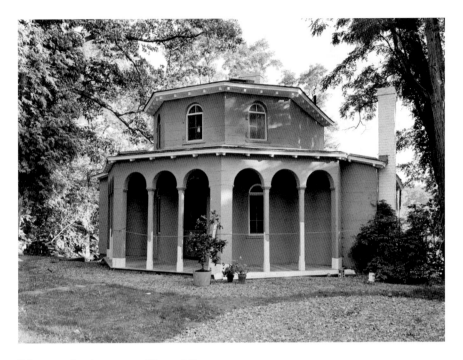

Edgewater South octagon. *Library of Congress.*

by Fowler. Each of the eight sides is sixteen feet high. On the top is an open cupola accessible by ladder from the second floor of the house. Around the turn of the century, the early stucco exterior was changed to clapboard to protect the fragile exterior walls.

In the Greene County town of Catskill is a red brick octagon house built in the 1860s by David Van Gelder. Van Gelder was a farmer and a designer of covered bridges. The home has two stories and a cupola. The exterior has a three-sided veranda, and brackets decorate the frieze board. The first floor has four rectangular rooms off a square center hall and four additional large rooms, with the corners forming closets. An open stairwell extends from the first floor to the windowed cupola.

Other Hudson Valley octagonal house examples include the Eastabrook House in Hoosick Falls, the Jenkins Octagon House and Schute Octagon House in Schenectady County. While traveling the Hudson Valley, you will undoubtedly find many, many more.

The Disappearance of Doodletown

Why an entire village or a perfectly lovely old town is abandoned is a mystery. Doodletown is no exception.

Along one of the most beautiful areas stretching the shores of the Hudson River, in a cove under four mountains in the northernmost portion of Rockland County, is the isolated hamlet of Doodletown—or rather, what remains of a town that vanished.

The land was originally the home of the Munsee Indians about five to ten thousand years ago until the year 1683, when it was purchased by Stephanus Van Cortlandt from the Haverstraw Indians.

The first settlers coming to this place in the rocky hills high above Iona Island were the Junes. Ithiel June founded Doodletown in 1762. He and his family were descendants of the French Huguenots who came to America in the seventeenth century by way of Switzerland, Holland, Germany and England when France's authorities were driving out Protestants. Their name, originally, might have been something like *Jouin* and later changed to June.

Giving up their beloved France for their religion, the Junes sailed across the sea for America, arriving in New York City in 1690. They gradually made their way up the Hudson River. The June family name appears on maps drawn in 1778 by Robert Erskine, the bright Scotsman who did so much to map the early colonies and who, under General George Washington, served as the surveyor general to the armies.

On the maps, the name "June"—the first settlers of Doodletown—appears twice where Doodletown Brook enters the marsh along Iona Island and at

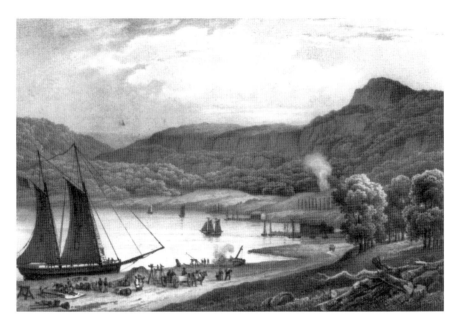

Haverstraw Landing, Adam Victor, lithographer, 1828. *Library of Congress.*

the head of the creek where large boats loaded iron ore and wood. June's Tavern is where George Washington often stopped en route from Newburgh to Morristown, New Jersey.

According to newspapers, one of the best remembered June family members was Uncle Cale, who served as head of the family and was on the staff of the Palisades Interstate Park. He was custodian of the Mule Field, which was the familiar name used for the storage of heavy material, logs and lumber and ironwork, which is just south of the present-day playground at Bear Mountain State Park.

Uncle Cale was also the preacher at the Methodist church in Doodletown. Cale's father was one of the earliest leaders of the church, and when he died, his son took up the task. Both men approached their work seriously and were often seen in Doodletown with a weathered copy of the Bible under their arms. Uncle Cale's great-grandfather was in the valley of Doodletown when Fort Clinton at Bear Mountain was taken by the British under Sir Henry Clinton in the year 1777. The original deed to his land, a subdivision of the Weyant Patent, is dated 1776, with most of the other holdings in Doodletown taken over by the park.

Before this exhibition of extreme eminent domain, Doodletown was a wild wonderland where oak trees stood five feet in diameter on the mountainsides

and were sometimes used as timber for shipbuilding. There were abundant chestnut trees yielding nuts. Hundreds of deer roamed the mountains, along with partridges, rabbits, rattlesnakes and copperheads.

Doodletown presumably got its name from the fiery Mad Anthony Wayne's British troops, who were playing "Yankee Doodle Dandy" on their fifes and drums as they descended from Dunderberg into the hamlet, which had no name at the time. Another story explains that the name comes from the Dutch words *dood* for "dead" and *del* for "dale or valley" and was given while C.C. Vermeule was first mapping the palisades section of the Interstate Park. Some believe that Doodletown means "Dead Hollow," which is possibly what the early sloop-skippers saw from their ships when they viewed the area's burned forests.

The June family, particularly Uncle Cale, had another explanation. He reported having received the history from his father that it wasn't the British who played "Yankee Doodle" on their fifes, but rather during the American Revolution, it was General Anthony Wayne who played "Yankee Doodle" on his way to the glorious recapture of Stony Point in July 1779. After going around the west side of Bear Mountain and crossing Popolopen Creek, his army followed the old Doodletown Road between Bear and West Mountains through Doodletown and up over Dunderberg Mountain, around the edge of what is known as Bald Hill and down to Stony Point.

In the late 1770s, Doodletown became known widely as the point at which resistance was first made to the British troops attempting to capture Forts Clinton and Montgomery. Stories have come and gone about the name possibly being derived from the fact that it was the first place in the Highlands that met the morning twilight and the first place where the roosters crowed (cock-a-doodle-doo), so naturally the name Doodletown seemed to fit. Later stories in the early twentieth century held that Doodletown should be rechristened as Montville, *mont* being the French word for "mountain" and *ville* for "city."

Yet with all this rich history, one still wonders why Doodletown died. The answer is that Doodletown did not just disappear; it was quite literally swallowed up, little by little, by a state park, starting in 1925 and ending in 1962.

Before the slow decline, Doodletown was home to hundreds of families with houses tucked away in the mountain coves and valleys. There were a few farms on the mountain hillsides, two small churches, a schoolhouse, a store and two cemeteries. Around the turn of the twentieth century, regulations were put in place by the State of New York on privately owned

woodlands, creating a forest reserve in the Highlands. These guidelines restricted residents from cutting down trees of a certain size and age. In certain locations, residents could not cut trees at all. The regulations were intended to prevent locals from clear-cutting whole hillsides down to the ground and leaving huge bare tracks of land. The Forest, Fish and Game Commission was also looking to purchase some of the land to be replanted by the state.

Around 1900, vacationers and day trippers took an enormous interest in land north of New York City. In 1919, the steamboat *Highlander* was put into service to allow passengers from New York City to travel roundtrip to the Palisades Interstate Park, which stretched along the Hudson River from Fort Lee, New Jersey, to Bear Mountain, for just fifty cents.

Before this time, a large majority of people accessing the park were campers, fishermen and anyone owning an automobile. The new affordable fifty-cent fare gave people of lesser means an opportunity to travel up the magnificent Hudson River and spend the day in the camp. The fare even included camping for those who wanted to perch on the top of the Palisades overnight to take in the spectacular views. One of the main attractions at the park was Hessian Pond, just south of Doodletown, where the bodies of fallen Hessian soldiers were disposed of during the time when the British and Hessian troops attacked Fort Clinton and Fort Montgomery. Remarkably, campers were also given free use of boats to paddle around the pond and search for possible Revolutionary War artifacts.

In fact, the remains of the Hessians' bodies and relics continued to surface in Doodletown over the years. Around 1909, Miss Maxon, a longtime resident and descendant of a man who fought the Hessians, displayed the wartime bayonet used by her ancestor beside the gate to her kitchen garden. Apparently, Doodletown was full of bayonets. According to some residents, they could be found everywhere from Bloody Pond to Stony Point. In fact, it was a particularly favored pastime of some of the town boys to take excursions on Bear Mountain searching for them. One newspaper reported that the boys not only found swords but also spurs and stirrup irons with the crest of the landgrave of Hesse-Casse stamped on them. Some say that the men in the town never bought shoes because if they needed a pair of boots, they simply walked along the shores of Bloody Pond until they found a pair.

While tourism was on the rise, there was also a steady march by many factions toward both preserving and developing the land in and around Doodletown, Bear Mountain and the Hudson Highlands. To draw attention to the area, New York State planned a celebration to commemorate Henry

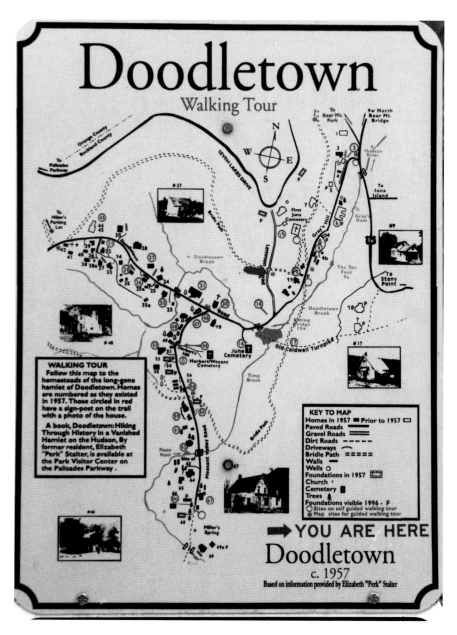

Map of Doodletown, an abandoned town located within Bear Mountain State Park, New York. *Wikimedia Commons*.

Hudson's 1609 exploration of the river and Robert Fulton's 1807 operation of a successful steamship. The huge festival received a lot of public interest and raised the general awareness in preservation of the natural beauty of this unique part of New York.

It was in 1895 that a group called the American Scenic and Historic Preservation Society argued for federal protection of sixty-five square miles on the east side of the Hudson and fifty-seven square miles on the west side. Though authorities in Washington, D.C., turned down the request, the New York legislature eventually passed a bill that set aside seventy-five square miles on the west side of the Hudson as the Highlands of the Hudson Forest Reserve.

But the battle for the Highlands raged on. While one group was petitioning to preserve it, another group was planning to build a prison on it. Construction plans for a $2 million prison at Bear Mountain were soon underway. The new place was to include a walled enclosure and eighteen buildings, an administration building, a cellblock with a capacity of 1,400 inmates, a mess hall and a chapel. Auxiliary buildings included a prison hospital to care for 75 patients and a building with thirty cells to isolate prisoners who were troublemakers. Prisons had already successfully made their way "up the river," including nearby Sing Sing in Ossining, New York.

Thankfully, the prison project never came to pass. The wealthy residents in the area who had second homes, including George W. Perkins, organized a fundraiser in which they solicited several well-known philanthropists. Millions of dollars poured into the Hudson Highland parks project. Those who contributed include railroad magnate Edward Harriman, J.D. Rockefeller and J.P. Morgan.

By 1927, nearly one thousand acres, thirty-four of which were in Doodletown, had been given to the Harriman State Park. And the sad news came down for Doodletown. To make way for the new park, several of the people living in town sold their homes and moved, and other homes were taken by way of eminent domain. Doodletown was dying, and the departure spurred stinging tears of loss and regret. Like a hero in any battle, the town was sacrificed in the name of preservation.

Today the area is a ghost town, with just a few lingering reminders that the acres were once home to hundreds of families from 1762 to 1965. It is now officially part of the Bear Mountain State Park. The old school and many ruins, stone walls, moss-covered concrete steps and fieldstone foundations are still visible. Hikers can explore various routes that reveal

some of the most fascinating remains. Along the way, sojourners can be on the lookout for Pleasant Valley and Gray's Hill, the roads traversed by British soldiers as they marched north to attack rebel forts during the Revolutionary War. Though Doodletown is officially dead, the Herbert Cemetery is still accessible. There in the deep woodland graveyard is the June family burial site amid ancient oak trees with hundreds of headstones of the deceased Doodletown pioneers laid to rest beneath age-old layers of Hudson Valley soil.

II

MID-HUDSON VALLEY

ORANGE, SULLIVAN AND
ULSTER COUNTIES

8

Amazing Mastodons

Many biology professionals have called Orange County, New York, the mastodon capital of the world. The first mastodon remains of Orange County were found by a ditch digger in 1780 on the farm of the Reverend Robert Annan and viewed by George Washington while he and his Continental army were encamped in Newburgh. Washington, it seemed, had a curiosity about the big bones and had already collected one from a site on the Ohio River. Thomas Jefferson also had a keen interest in natural history and collected the bones as well. Other famous Americans became mesmerized by the huge unidentified beasts, including Kentucky pioneer Daniel Boone and Puritan preacher Cotton Mather. It is also believed that Lewis and Clark were in search of not just mastodon bones on their exploration of the West but possibly living mammoths.

The curious number of *Mammut americanum* uncovered in the Hudson Valley is quite mind numbing, with seventy discovered in Orange County's vast mastodon graveyard. Since the world's very first mastodon tooth rolled down a farmer's hill in Claverack, New York, in 1705, bones, shoulder blades, teeth and skulls keep popping up in New York as a natural result of humans excavating the earth for the purpose of building or planting. Finding the remains of these mega animals is still incredibly exciting because it's just by sheer luck that these remains have survived considering how long they have been lying under the earth. And despite the abundance of discoveries in New York, finding a bone is still quite rare.

Here are a few notable facts about mastodons. Mastodons are large shaggy prehistoric elephants. They are often confused with woolly mammoths. The mastodon's official genus is *Mammut*. French naturalist Georges Cuvier coined the name, which translates to "nipple," as a mastodon tooth resembles a human breast.

The mastodon possibly found its way to North America about thirty million years ago when a group of prehistoric elephants from Africa migrated through Eurasia and traveled across the Siberian land bridge.

These big animals were plant eaters, and they liked to graze on a variety of shrubs and trees. Another distinguishing feature—the tusks—were used to secure a mate and defend against predators like the saber-toothed tiger. Generally, these huge beasts were solitary creatures that came together occasionally to find partners.

Mastodons died off about eleven thousand years ago for a number of reasons, including the ice age climate conditions, lack of food and the idea that when the animals came in contact with humans they caught tuberculosis. Sadly, mastodons were also hunted as a food source for tribes of early settlers. These impressive giants also fed in swampy wetland areas and bogs and possibly got stuck in the muck.

One of the Hudson Valley's claims to fame is that the earliest mastodon bones were found in Claverack, New York, around the year 1705. A local farmer plowing his field noticed a big object roll down the hill where he was working. It turned out that the object was a five-pound tooth. Not immediately recognizing the significance of the historic find, the farmer traded the unusual tooth to a local politician for a mere tumbler of good rum. The politician, in turn, gave it to the governor of New York, who then shipped it to Lord Cornbury, who sent the specimen to the security of the Royal Society of England.

Lord Cornbury, writing from a New York address, gives an account of the continuing excavation of the Claverack farm site, which was carried out under his direction. Here's a bit of the letter extracted from a *Museum Bulletin* article titled "The Mastodons, Mammoths and Other Pleistocene Mammals of New York State," written by Chris Andrew Hartnagel and Sherman Chauncey Bishop:

> *I did, by the Virginia fleet, send you a Tooth, which, on the outside of the box, was called the tooth of a Giant, and I desired it might be given to Gresham College: I now send you some of his bones, and I am able to give you this account. The tooth I sent was found near the side of Hudson's*

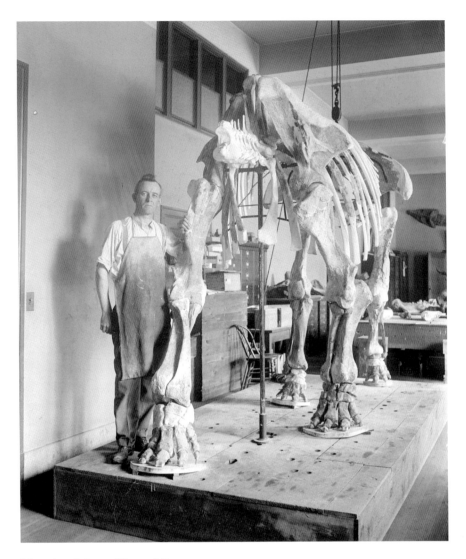

Mastodon skeleton. *Library of Congress.*

River, rolled down from a high bank by a Dutch country fellow, about twenty miles on this side of Albany, and sold to one Van Bruggen for a gill of rum. Van Bruggen being a member of the Assembly, and coming down to New York to the Assembly, brought the tooth with him, and show'd it to several people here. I was told of it, and sent for it to see, and ask'd if he would dispose of it; he said it was worth nothing, but if I had a mind to it, 'twas at my service.

The letter then goes on to tell how astonished they were at the finding: "Some said 'twas the tooth of a human creature others, of some beast or fish; but nobody could tell what beast or fish had such a tooth."

Cornbury continued:

I was of opinion it was the tooth of a giant, which gave me the curiosity to enquire farther. One Mr. Abeel, Recorder of Albany, was then in town, so I directed him to send some person to dig near the place where the tooth was found; which he did, and that you may see the account he gives me of it, I send you the original letter he sent to me; you must allow for the bad English. I desire these bones may be sent to the tooth, if you think fit.

Mr. Abeel reported his find:

According to you Excellency's order, I sent to Klavern to make a further discover about the bones of that creature where the great tooth of it was found. They have dug on the top of the bank where the tooth was roll'd down from, and they found, fifteen feet underground, the bones of a corpse that was thirty feet long, but was almost all decayed; so soon as they handled them they broke in pieces; they took up some of the firm pieces, and sent them to me, and I have ordered them to be delivered to your Excellency.

From that point forward, the uncovered mastodon from Claverack quickly became known as the "Incognitium" or the famous "unknown thing."

Just after the find in Claverack, mastodon remains were found in Coxsackie, just south of Albany, in 1706, making it the second discovery in America. The American Antiquarian Society of Worcester has a letter written by Cotton Mather (of the Salem witch trials fame) to Governor Joseph Dudley that contains an account of the mastodon remains found near Albany.

With regard to downriver discoveries, two mastodon skeletons were found in a pond about three miles north of Poughkeepsie. One was discovered buried in a marsh, and the other was found closer to the city. The find is described in a letter dated September 22, 1854, and written by Spencer F. Baird, the former secretary of the Smithsonian Institution. He said:

When at Poughkeepsie yesterday morning, I learned that some large bones, supposed to be mastodon, had been discovered in digging marl near the city. The bones found appear to have been a large vertebra and some splinters of other bones lying in the shelly marl bed.

In September 1866, the larger lower jaw and the fantastic foot of a mastodon were discovered on a rocky ledge near a pothole in Cohoes where men were working on excavating a foundation for the new Harmony Mill (later called Mastodon Mill). The skeleton of the Cohoes mastodon offered curious clues as to how mastodons may have lived. Above the bones was about sixty feet of mossy, peaty soil filled with rotted wood limbs that had been gnawed by beavers. Scientists believed that the area where the bones were found was once a large swamp, providing the beasts with a perfect feeding ground.

In 1899, more mastodon remains turned up in Hyde Park. The *New York Herald* wrote this about the amazing discovery:

> *Portions of a mastodon have been found in Dutchess County, in a swamp on the old Macpherson place, in the Hyde Park Road near the country homes of Frederick W. Vanderbilt and other prominent New York persons. Workmen digging a drain found several fragments of heavy bone 15 feet below the surface, and some feet deeper part of a mammoth tusk. Mr. Edward Storrs Atwater, a wealthy resident of this city, has obtained the*

Harmony Mill No. 3 (Mastodon Mill). *Library of Congress.*

bone and will present it to Vassar College. The college officials are delirious
of making further excavations in the hope of unearthing the entire skeleton.
They also believe other skeletons may be found there.

The same article includes information on another find in Newburgh on the opposite side of the Hudson.

Farther south, in 1840, a mastodon was supposedly found in Manhattan during the digging of the cellar of J.M. Broadhurst's house on Broadway near Franklin Street. Also near a section of Inwood, Elisha A. Howland, the principal of grammar school No. 68 at 128th Street between 6th and 7th Avenues, found a fifteen-inch mastodon tusk in 1885 while cutting a ditch through a peat bed near the Presbyterian church. Another three-foot-long tusk was found that same year near the salt meadow of Harlem's ship canal (now the Harlem River). Both tusks were donated to the American Museum of Natural History.

One of the most astounding stories relates to the skeleton found near the Hudson River in the fall of 1780 in Orange County. In 1799, Thomas Jefferson organized a committee to find skeletons of the so-called mammoth in America. Jefferson was, among other great accomplishments, the trustee of North America's first natural history museum, founded by George Willson Peale. Peale, a former saddler, was a well-known portrait painter and developed paintings that portrayed significant figures like George Washington. Peale founded his own museum in Baltimore and filled it with paintings, natural science specimens and unusual artifacts that told the story of eighteenth-century American life. Peale was also a supporter of Jefferson and was added to the committee.

In 1783, Peale created a drawing of a mastodon tooth, which led him to amass a huge assortment of bones for his Philadelphia collection. When the news of the Orange County mastodon discovery on the farm of John Masten arrived, he raced to New York to see the skeleton for himself.

By the time he arrived on the site, many of the pieces had been stolen by treasure hunters. He and Jefferson quickly used their funds and wit to take over the enterprise in Montgomery, New York. Within a short few weeks, they excavation was fully underway, including the use of the now famous bucket-wheel apparatus used to drain the swampy water out of the pit where the mastodon lay. The entire elaborate scene was captured in perpetuity in Peale's renowned 1806 painting *Exhumation of the Mastodon.*

As it turned out, the Masten site revealed one enormous eleven-foot tusk, but nothing much else was dug out of the pit. Locals directed Peale and his

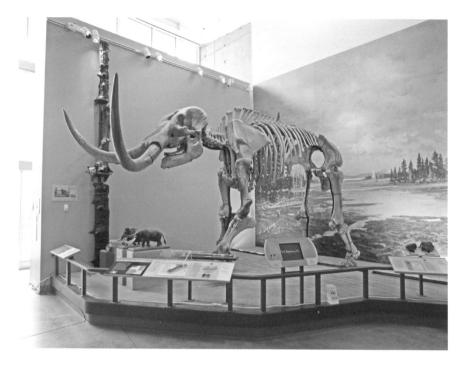

Orange County mastodon. *Courtesy of the Paleontological Research Institution, Ithaca, New York.*

crew to investigate another possible site not far away at the farm of Peter Millspaw. It was there that Peale uncovered a complete mastodon skeleton, including vertebrae, leg bones and four teeth and, by some reports, tufts of hair. In all, Peale found three individual mastodons.

For safekeeping, he shipped the treasured bones off to Philadelphia for public viewing at the Philosophical Hall in his museum—until his establishment failed. When the museum went into bankruptcy, the first mastodon skeleton was sold to German investors in 1848. For over a century, the skeleton disappeared from American history. The missing mastodon specimen had apparently been sold to a private individual and surfaced in the 1950s in the Hessisches Landes Museum in Darmstadt, Germany, where it is displayed today. The second mastodon was sold to the New York Museum of Natural History.

The tale of Peale's many (some missing) mastodons was preserved by his son, Rembrandt Peale, in his painting *Disquisition on the Mammoth, or, Great American Incognitum* (London, 1803). The magnificent work provides a firsthand account of the excavation of Peale's amazing mastodon.

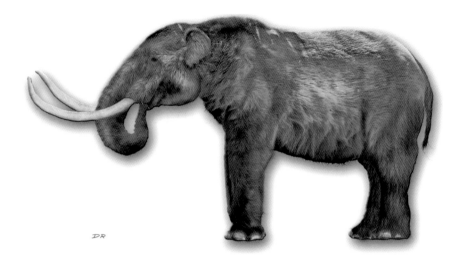

Mastodon illustration. *Library of Congress.*

While it would be great fun to map out all of the many places that the mighty mastodon bones have turned up in the Hudson Valley and beyond, the list runs a bit too long for just one book chapter. For now, it may suffice to say that these giant beasts have created widespread interest for hundreds of years and continue to find a place of honor in New York's curious past. And you never know; with many mastodons having roamed the region, you might even be lucky enough to find one in your own backyard.

Eleanor Roosevelt's Romantic Revolver

In 1987, a strange half-page advertisement appeared in the *East Hampton Star*. It read, "If James Cagney and Eleanor Roosevelt were alive today and attended a black tie dinner in the Big Apple, Mayor Koch would have them arrested!" This ad was pointing out that Eleanor Roosevelt, at age seventy-two, had obtained a pistol license issued in Dutchess County. Yet at the time, carrying a concealed weapon was illegal in New York City, and if Mrs. Roosevelt were to carry her pistol, she would have been subject to a year in prison.

No one can deny that Eleanor Roosevelt, the wife of President Franklin Delano Roosevelt, was indeed unique. And it is true; she was a gun owner. A permit to carry a pistol was issued to Eleanor on August 5, 1957, in Dutchess County. As the story goes, it seems that Eleanor wasn't particularly fond of the Secret Service protection that her husband's administration insisted accompany her after a 1933 assassination attempt was made on FDR's life.

Eleanor, however, was a free spirit. She rode horses, she had fun with her friends and she liked to roam the woods in Hyde Park and at her private cottage, Val-Kill. Eleanor loved to swim in the estate's clear ponds, and she had a pool installed as well. She played tennis, and she especially liked to drive and travel unencumbered. So instead of the Secret Service securing her protection, Eleanor became a pretty good shot with her handgun: a .22 Smith & Wesson Outdoorsman revolver, to be exact.

The gun was a personal gift from her bodyguard, Earl Miller, who was assigned to protect Eleanor in 1928 when FDR was elected New York State governor. It was also Earl who taught Eleanor how to shoot the firearm.

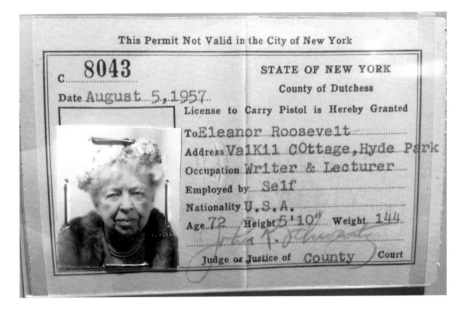

Eleanor Roosevelt's gun license. *Library of Congress.*

Eleanor herself confessed that she was a decent shot, and she carried her revolver in the glove compartment of her car when she traveled—sometimes she carried it on her person.

Eleanor also said this in her daily column, "My Day," published on March 13, 1937.

He was the son of my hostess at one of my stops and he had read that I carried a gun with me! Someone had evidently forgotten to mention what I actually said, namely, that when I motored and was driving my own car by myself, that the Secret Service had asked me to carry a pistol and that I did it and had learned how to use it! I do not mean by this of course, that I am an expert shot, I only wish I were, and if inheritance has anything to do with it, I ought to be for my father could hold his own even in the west in those early days when my uncle, Theodore Roosevelt, had a ranch in the Dakotas. These things do not however, go by inheritance and my opportunities for shooting have been few and far between, but if the necessity arose, I do know how to use a pistol.

While the gun was there for her protection, Eleanor believed in safety. "After considerable practice, I finally learned to hit a target," Roosevelt recalled in her book. "I would never have used it on a human being, but

I thought that I ought to know how to handle a revolver if I had one in my possession."

The gun that Earl Miller gave to Eleanor Roosevelt on her forty-ninth birthday started a passionate chain reaction of events between the two that is well documented but not often discussed.

Earl was a handsome ex-boxer and a state trooper when he was first assigned to the executive mansion in Albany. FDR had first met Miller in 1912 when FDR was assistant secretary of the navy touring battle areas in England and France; Miller was a chief petty officer assigned to guard him on his visit. Miller soon became FDR's first choice for protection.

After Miller was assigned to Eleanor, they became unusually friendly. Though there was a wide difference in age, they shared significant similarities. Eleanor and Earl were both orphans; she lost her parents at age ten, and he became a street kid at age twelve, picked up odd jobs and worked as a stunt man/contortionist in the circus. Earl showed Eleanor both respect and affection, and in return, Eleanor took him into her confidence. The friendship blossomed, and the pair went from sharing simple outings—which included sports she had greatly enjoyed before marrying her husband—to long weekends in the country and at the beach.

Earl gave Eleanor gifts, the most precious being a mare named Dot. This horse was dear to Eleanor's heart, and she rode her every day in Hyde Park. Earl also built Eleanor a tennis court where she could practice daily and went with her to the shooting range. Against protests from her family, Earl even taught Eleanor how to dive, a strange obsession she was determined to master.

Eleanor's son James was one of the few people who wrote about his mother's romantic involvement with Miller. "I believe there may have been one real romance in my mother's life outside of her marriage. Mother may have had an affair with Earl Miller."

In 1948, Earl Miller's love life made headline news in Albany when his third wife, Simone Van Haver, sued him for divorce. His second marriage, to seventeen-year-old Ruth Bellinger, was annulled. The wedding took place at the Roosevelt Estate in Hyde Park in 1937. Roosevelt's daughter, Anna, was the matron of honor, and Elliott Roosevelt was best man. The president and his wife were attending guests. Earl's first marriage ended just as swiftly.

The separation suit reported in the *Albany Times Union* accused Miller of "consorting with a woman of prominent reputation." The papers made a point of noting that Miller's separation from his two children, Earl Jr., age six, and Anna Eleanor, age three, was especially

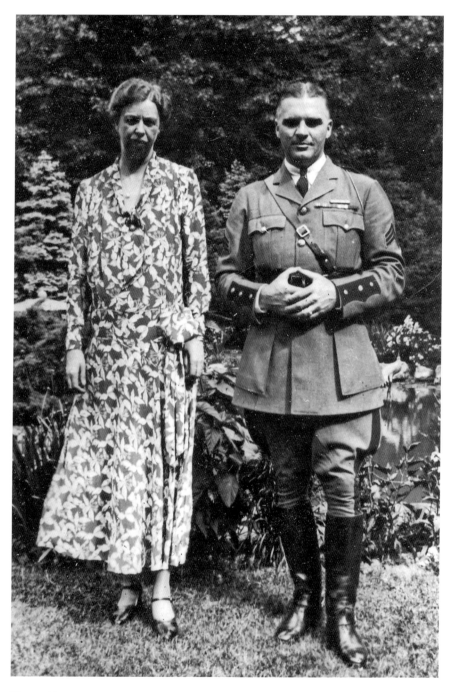

Eleanor Roosevelt and Earl Miller, 1930. *Library of Congress.*

wrenching. In an affidavit, Miller admitted to his wife's charges that he "openly consorted with various female companions, and in particular consorted openly and notoriously with one female friend." The identity of the "mystery woman" was never revealed, and the person's name had as much bearing on the case as did Mrs. Miller's allegations that her husband had caused her humiliation and embarrassment. She said he was "insulting, niggardly, petty, failed to adequately provide for herself and her children, and has struck and beaten her."

Eleanor's friendship with Miller reportedly began around the same time as her husband's rumored relationship with his secretary, Marguerite LeHand. Previously, in September 1918, while unpacking a suitcase of Franklin's, Eleanor discovered a package of love letters written to him by her social secretary, Lucy Mercer, confirming another affair.

The volumes of letters and correspondence between Eleanor Roosevelt and Earl Miller have curiously disappeared from the history files, yet the pistol he gave her surfaced in a recent auction, adding a bit more mystery to the relationship between ER and EM.

James D. Julia Auctioneers in Maine recently sold Eleanor Roosevelt's pistol in October 2014 to a private collector for $50,600. The gun is described as a blue-finished gun with a six-inch barrel, partridge front sight and a round top frame with an adjustable rear sight. It is detailed with smooth two-piece pearl grips, its original silver medallion and diamond-checkered, matched, numbered walnut grips. The silver plaque on the lid of the gun case is engraved, "OCT. 11, 1933 / May your aims always be perfect / EARL."

10

Creepy Vassar College

There is no shortage of strange and creepy stories of witchcraft, mummies and unexplained mysteries oozing from Vassar College's ivy-covered walls. Though Vassar has a long list of distinguished alumni and the school holds a vast and important collection of rare books and documents, like a copy of the Declaration of Independence, Elizabeth Cady Stanton papers and letters from Albert Einstein, it also possesses some lesser-known buried treasures.

Among the generally bizarre items in the Vassar archive is a songbook printed in 1881. In it is the music and verse to "Ring Ye Bells of Morning Death Story," a tune that was sung by the school's glee club members. The song tells the story of two unfortunate students who consistently are tardy for breakfast. As punishment, they were denied entry. And then this happened:

Alas, that there in Plenty's land,
While yet so young and fair,
The perils of starvation
Them in the face should stare.

Their faces grew all wan and sharp,
Their hands as thin as air,
And scarce their feeble tottering limbs,
Their wasted frames could bear.
One evening when the bells tolled out
A melancholy sound,

Vassar College drive, 1921. *Library of Congress.*

In Death's embrace these two were held,
And stark and stiff were found.

The Vassar mummy also falls into the category of curious and creepy objects. The late Egyptian mummy was purchased in London by two Vassar professors in 1890. When it arrived at the school, it was housed in the Loeb, Vassar's very own on-campus art museum. Vassar was one of the first colleges to include an art museum in its original plans, and it houses a priceless Hudson River Valley landscape collection, including works of Frederic Edwin Church and others.

The mummy was also displayed in the classics department through most of the twentieth century. When it suffered damage to its cartonnage (the colorful protective outer surface of the mummified body made from painted, plastered layers of fiber or papyrus), the mummy was moved.

In recent years, the mummy underwent tests to reveal that inside the decorative case is the body of a teenager. His name is Shep-en-Min, and he

died around 600 BCE. The teen was a priest of the fertility god Min. Shep-en-Min is from Akhmim, 290 miles sound of Cairo. By sheer coincidence, Shep-en-Min's mummified father is held in another area museum in the Berkshires.

Vassar's curious collections of super strange artifacts also include rocks. These aren't just any rocks; they are one of the country's most astounding college collections of geological wonders.

Earth science (formerly geology) and geography classes have been taught at Vassar since the college's opening in 1865. Sanborn Tenney, Vassar's first professor of natural history, taught courses in geology, mineralogy, botany, zoology and physical geography. College founder Matthew Vassar had one of the first cabinets of mineral and rock specimens installed in 1862. The school's holdings are known as one of the most complete and best arranged collections of specimens of rocks in the country.

As we progress down the list of oddities related to Vassar, there are a few more that truly baffle the mind. Vassar College is probably one of the only schools that offers a scholarship available only to students who can prove they are descendants of an 1800s benefactor, Calvin Huntington. The funds are also offered to anyone who is willing to change his or her middle name to his last name, Huntington.

The weird gets weirder when in 1986, Reuters News Service and the AP Newswire reported on a young priest at St. Philip's Episcopal Church in

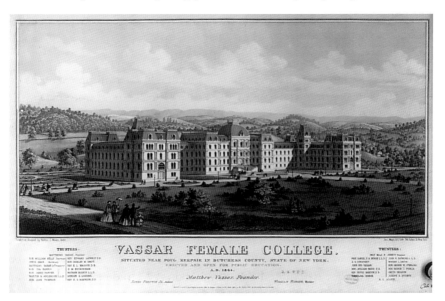

Vassar College, 1862. *Library of Congress.*

Charleston, South Carolina, who hastily resigned his position. In front of a stunned parish, the beloved forty-one-year-old Reverend Henry Scott gave his final sermon, explaining to his congregation that as a "happy-go-lucky" college student in 1967, he dated a woman from Vassar College who "told me that she was a witch." When the relationship ended, Scott said, "she put a curse on me." No one can say whether said student had a connection to the college's production of *Ye Laste Days of Vassalem Wytchcraft.*

And no discussion of this famous Hudson Valley educational institution would ever be complete without mentioning Anita Florence Hemmings and her incredible Vassar history.

The headline of the 1897 New York *Courtland Standard* was shocking to most who read the paper then, and it still remains shocking today. It read, "Colored Vassar Girl: The People at Poughkeepsie thought Miss Hemmings was a Spaniard."

Born in Boston, Anita Hemmings became famous by daring to enroll and graduate from the exclusive women's college when she knew that there was "negro blood in her veins," said the paper. It was the policy of Vassar at that time to admit only white women, with no exceptions. Because Anita was from a mixed-race family, she showed few traces of her true heritage, and therefore, she simply applied to Vassar and went.

The scandal was revealed after Hemmings graduated. Newspapers spread the scandal widely: "She was dark. It is true, but her complexion was rich and beautiful, and no one ever suspected her of being anything other than what she represented herself to be, a 'blue blooded' daughter of New England. Her hair was black and straight, worn usually in a knot at the back of her head. Her eyes were black and brilliant."

And they wrote this: "The girl took a prominent part in the exercises of class day, and not one who saw the class of '97 leave the shades of Vassar suspected negro blood in one whom all voted the class beauty."

It's worth reviewing the history of the late 1890s to understand why this was so troublesome for so many. At the time Anita Hemmings entered Vassar, the Thirteenth Amendment to the Constitution was just a little over thirty years old. In 1896, the Supreme Court upheld racial segregation laws, and African Americans were unable to participate in the political system, which persisted into the 1960s.

The outrage of the college staff and a few of her fellow classmates eventually subsided, and Anita went to work for the Boston Library. Coincidentally, her daughter, Ellen Love Atkin '27, graduated from Vassar thirty years later as a white woman.

Brewer, philanthropist and founder of Vassar, Matthew Vassar, 1898. *Wikimedia Commons.*

The unsettling history of Vassar College and the creepiness that surrounds this famous Hudson Valley campus may have started with its founder, Matthew Vassar, a former beer maker, who died mid-speech while delivering his farewell address to the college board of trustees.

Matthew Vassar's strange life started when he was born in Norfolk, England, in 1792. When he was just four years old, he traveled to America with his parents and siblings and was nearly carried overboard by a gigantic wave that collided with the ship. This near-death experience set the tone for Matthew Vassar's life, which was riddled with sickness, missteps and a number of narrow escapes from death.

One of his earliest memories was falling into the family pond and almost drowning after tumbling off his father's horse. After his family settled in Poughkeepsie on a family farm, Vassar was also bitten by a venomous snake, and he contracted typhus on three separate occasions. Each time he survived—barely.

After emigrating from England, Vassar's family purchased a 180-acre farm near the Wappinger's Creek, three miles from Poughkeepsie, with scenery reminiscent of their beloved Norfolk and close to a few other English families. They immediately noticed the abundance of wild hop vines growing along their property and hanging from saplings, reminding them of their old home-brewed English ale. Soon the family was the first to have a field of barley growing in Dutchess County in 1794.

Mathew's father, James, spent his time running the farm and making and selling real English ale, which quickly became popular with local neighbors and townspeople. Matthew and his mother drove the family's wagon to market, delivering farm-fresh eggs, milk and barrels of ale to a growing group of customers. By 1801, the demand for the Vassars' ale had become so large that James sold the family farm and started a brewing business in Poughkeepsie.

The senior Vassar fully expected his sons to become assistants in the thriving business. Matthew's brother took to the trade, but Matthew wanted no part of it. He found the business rather distasteful, and because of his defiance, he was immediately indentured to a local tanner to work long hours for little pay.

Dissatisfied with his situation, he promptly escaped. In 1806, with his mother's help, Vassar fled, walking eight miles to a nearby Hamburg ferry with just seventy-five cents and some handmade clothing. He traveled across the river to Newburgh, securing a position with a farmer's son as a country storekeeper.

As an independent, the young Matthew Vassar did quite well and returned to his family just a few years later with over $150. He entered the family business briefly, but on May 10, 1811, the entire establishment burned to the ground. Tragedy struck twice, and within a few short days, his brother John Guy, at age twenty-two, suffocated on carbonic acid gas emanating from a recently emptied beer vat in the building ruins.

With what slim funds he had left, Matthew leased the basement of the county courthouse to sell his ale and oysters in 1812. He delivered small batches of ale himself, and the brewing business grew. The result was the area's very first "oyster saloon," which quickly became a favorite watering hole for lawyers and politicians.

Despite his deep dislike for the beer business originally, Vassar made a fortune in the industry. He married late in his life, and being a man without any children, he decided to take his wealth and find a new direction.

In 1845, he traveled to England with his wife. After visiting a hospital founded by Thomas Guy, a distant relative, Vassar was inspired to give a great portion of his wealth to a benevolent cause to promote the general welfare of society. He decided that cause would be women's education.

Vassar said, "It occurred to me that women having received from her Creator, the same intellectual constitution as men, has the same right as man to intellectual culture and development. It is my hope to be the instrument in the hand of providence of founding an institution which shall accomplish for young women what the colleges are accomplishing for men." Matthew Vassar took this pledge seriously and committed his extensive wealth to accomplish this endeavor. To get his college rolling, he put up $400,000 and the land.

A charter was granted to Vassar Female College in January 1861. The word "female" was eventually dropped from the title, but the school remained exclusive to female students. Matthew Vassar took great pride in publicly praising his future students. "I consider that the mothers of the country mold its citizens, determine its institutions and shape its destiny." The day it opened, Vassar College already had 850 students ready to enroll.

Matthew Vassar's strange death occurred just seven years after he started the college in 1868. The minutes of the board meeting where he died literally in mid-sentence describe in full detail what occurred:

> [He] *was reading from the eleventh page when he failed to pronounce a word which was upon his lips, dropped the papers from his hand, fell back in his chair insensible, and died at precisely ten minutes to 12 o'clock AM by the clock in the College Tower.*

The trustees in the meeting found cause to take a break only after they said a prayer over Vassar's dead body. The board chair astonishingly then decided to continue the meeting, believing that Matthew would have wanted it that way, so he went up to the podium and proceeded to finish reading Matthew's speech. In what could be considered a prophetic moment, the speech that Vassar was delivering pointed out how extremely lucky they all were not to have had a death or serious illness among the board members or students in the first three years of the college's opening.

The Irony of Neversink

With a name like Neversink, it seems ironic that the town would have been submerged under water—wiped off the face of the earth.

To understand the true tragedy of such an event, it is necessary to trace Old Neversink, as it was known, to its beautiful beginnings before it was lost forever—drowned, so to speak—to allow the State of New York to form the Neversink Reservoir.

Neversink became a formal town by an act of the Ulster County legislature in March 1798. In those early years, the town got tossed from one county to another until it landed in Sullivan County in the 1800s.

Prior to 1788, except for the few families located in the valley of the Lackawack, it was believed that there were no white residents of Neversink. Native Americans of the Lenape tribe called the area *Ne-wa-sink*, of which there are a few different meanings. One theory is that it means "mad river," describing the wild and turbulent nature of the Neversink River. A second explanation is that the word means a "continual running stream," or one that *never sinks* into the ground. The third probable definition is in *Webster's Dictionary* and is said to mean "highland between waters," describing, perhaps, where it is located.

At the turn of the century, dating back to 1905, the New York State legislature passed Chapter 724, a set of laws allowing New York City to acquire lands and build dams, reservoirs and aqueducts in the Catskills. The city had long since claimed the Croton River watershed in Putnam and Westchester Counties east of the Hudson, drawing its water from reservoirs and lakes in that region since 1842.

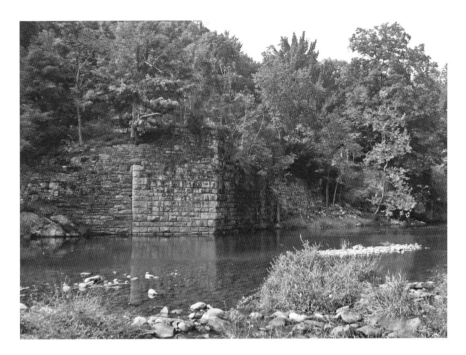

D&H Canal, Neversink. *Library of Congress.*

It took a while, but true trouble came to Neversink and neighboring towns when in the 1930s, New York City officials decided they could create a reliable water supply for the growing metropolis by building a reservoir upstate. Rights were obtained from the Rockland Light and Power Company. The Roundout Reservoir, straddling the Ulster and Sullivan County line, was built between 1937 and 1954. The Neversink Reservoir—a few miles distant in Sullivan County—was planned for construction between 1941 and 1953. Both projects were delayed during the World War II years but resumed in 1946.

In 1939, the *Kingston Daily Freeman* ran articles updating citizens on the progress of the impending project, which intended to "throw a dam across the Neversink River and dam up the stream," creating a flow line. The newspaper revealed the startling fact that there was an intention on the part of city officials to relocate many roads and utility lines. But that wasn't the worst of it. "Route 55 from Grahamsville to Liberty will be relocated along the reservoir and will run below the main dam across the Neversink and on the south side of the reservoir along the town of Fallsburg line," read the news. Then came this dreadful headline: "A part of the takings

will be in the town of Fallsburg, but the majority of the land will be in the town of Neversink."

While the building of the dam was a lifeboat for the millions of residents of New York City's five boroughs who would be benefiting from the crisp, clear, clean Catskill water, it was a death sentence for the people and land in Neversink. If the officials went through with their proposals, it meant that Neversink would be submerged under many feet of water, and the massive watershed would cover some seventy miles.

With a harshness that few residents could believe, the newspaper indicated that commissioners of appraisals for the City of New York published a long list of private lands—some of which had been in families for generations—that would be taken and the amounts to be paid to the owners for the land. The locations of the land parcels, the size and the owners' names appeared at the bottom of the *Kingston Daily* newspaper article. The news was tragic and shocking, and it hit the townspeople like a report of whole groups of people dying in an avalanche or an earthquake, all at once, suddenly gone in a flash.

What wasn't generally known was that for many, Neversink was sacred ground. It existed high up on a mountain. It was the place where people would go when they longed to escape the noise, the grime and the congestion that comes when too many bodies take up too little space in a large city. Neversink drew people into its magical outdoors, where they could walk in hemlock forests, camp on beds of soft pine needles, swim under crashing fresh waterfalls, fish for river trout and search the night skies for shooting stars. And because of its beauty, the town is immortalized in a famous poem, "The Mountaineer of Neversink," by Patterson Du Bois:

> *To bide my sweetest tryst, the commonplace to flee,*
> *And fuse my soul with Nature's sympathy;*
> *I trod the path down the glen cascade,*
> *I marked the wrestling of the sun-flecked shade,*
> *I stepped from rock to rock amid the foam,*
> *And Nature seemed my temple and my home.*

Losing this special land stirred a resistance. Not all residents went down without a fight. Since the project took multiple years to complete, there was plenty of time for complaints.

In 1943, the *Kingston Freeman* reported that Dr. Henry C. McBrair, a dentist from Middletown, New York, filed a $12,827,321 claim against New York

Neversink during destruction.
Wikimedia Commons.

City for alleged destruction of water rights on the upper Neversink River. He claimed exclusive ownership by purchase of water rights near Cuddeback, which he says were made useless by the city's $300 million project. His lawyer added that the figure was determined on a "gallonage basis."

Often, over its history, Neversink had a habit of taking on excessive water by way of natural causes. On Friday the Thirteenth in December 1878, the *Tri-State Union* newspaper in Port Jervis, Orange County, reported a disastrous winter flood whereby the sudden rise of the Neversink River caused parts of the cemetery to become submerged. Friends and relatives of the deceased were keenly concerned with the backwaters and possible damage to family graves and remains. Homes higher up from the river, including a cattle yard, had barns that flooded. The rising water was so high in some stockyards that farm animals resorted to swimming in their pens until they were rescued.

Several houses along the river were completely submerged, with basements taking on some six feet of water. The paper reported, "The mountain rivulets, suddenly converted into impetuous torrents, invaded cellars, wells, cisterns, and door-yards, doing considerable damage."

The flood even threatened the foundation of the town's toll gate house, which was occupied at the time by a Mr. Matthews and his family. As the structure began to give way, a part of the road crumbled, and before the family could grab their valuables, the building fell and a strong river current rushed in. The local bridge was also in danger of giving out, causing hundreds of townspeople to rush out of their homes to save it. They moved quickly, employing a number of carts to bring heavy loads of stone to the pier near the bridge, and they were able to create a barricade—though the washout was extensive. To try to secure the tower of the toll gate, the residents used heavy chains to attempt to buoy it up. The settlers in the town

agreed that they had never witnessed the Delaware and the Neversink Rivers rise so high. The D&H Canal lost huge chunks of earth washed out by the mountain streams. Several houses received so much damage that residents were forced to move out.

But the dam project forcing the death of Neversink was by no means brought on by natural waters. By the end of the project in the 1950s, the communities of Eureka, Montela and Lackawack were eliminated to make way for the Rondout, with the Neversink and Bittersweet completely lost to the Neversink Reservoir.

In all, more than 1,500 people were forced to vacate their homes, farms and businesses in both valleys so that New York City could submerge the family properties held for generations under millions of gallons of water. Some say that the submerged town is still visible, like a great ship sunk at the bottom of the sea.

Bittersweet was also removed with Neversink to make way for the reservoir. According to the Center for Land Use Protection, approximately 340 people were eventually evicted from the valley and 6,149 acres condemned. Some buildings were relocated to nearby towns, though most were bulldozed and burned in a "final harvest." Trees were removed, cellars were filled in, privies were disinfected and even barnyard manure was said to have been dug up to maintain New York City's reputation for having the finest drinking water possible. The Neversink Reservoir began to flood the land on June 4, 1953, and it took two years to fill.

The *final harvest* refers perhaps to another poem, this one written by Emily Dickinson. It sums up the irony of Neversink:

> *I felt a funeral in my brain,*
> *And mourners to and fro*
> *Kept treading—treading till it seemed*
> *That sense was breaking through*
>
> *And when they all were seated*
> *A service like a drum,*
> *Kept beating, beating till I thought*
> *My mind was going numb*
>
> *And then I heard them lift a box*
> *And creak across my soul*
> *With those same boots of lead again,*
> *Then space—began to toll*

And all the heavens were a bell
And being but an ear
And I, and Silence, and some strange Race
Wrecked solitary here.

And then a plank in reason, broke,
And I dropped down and down—
And hit a world at every plunge,
And Finished knowing—Then—

After the reservoir was complete, the village of Neversink relocated to its present site along Route 55, and a museum was established to preserve the story.

One last bit of irony related to Neversink's status as a wet or dry town has nothing to do with water but everything to do with alcohol. In 1935, town officials passed a law prohibiting the sale of alcohol, which meant no one could buy a glass of wine at a restaurant or a six-pack of beer at the convenience store. No one could purchase a bottle of champagne on New Year's Eve or obtain a snifter of brandy on a frigid night. No alcohol, not a single drop, nothing. The ban went into place two years after Prohibition was repealed. Remarkably, the ban stayed in place for more than eighty years, until 2015, when the town agreed to allow alcohol to be served in restaurants but not purchased in stores. Neversink is one of twelve dry towns in New York State.

12

The Wickedest Man on Earth

He has been called the Wickedest Man on Earth, the Hermit of the Esopus Island, a modern mystic, a monster and a magician. Aleister Crowley was many things, but he was anything but ordinary.

Near the town of Hyde Park on the eastern side of the Hudson River about eighty-five miles north of New York City is the tiny one-mile-long Esopus Island. The island was originally Native American ground of the Lenape tribe. In 1918, completely broke, Aleister Crowley took up solitary residence on this spit of land in the upper Hudson Valley to embark on a spiritual journey.

Aleister Crowley was forty-two years old the summer he haunted the Hudson Valley shores in August 1918. In the moonlight, beside his campfire, with his shiny bald head bouncing and a ponytail forelock dancing all around, Crowley chanted songs of ancient pagan rituals on the remote Esopus Island. The sight of him in a robe-like shirt, hiking boots, shorts and blazing red tassels on his golf socks probably scared away any potential visitors.

He referred to his retreat on the island as a "great magical retirement," completing a full forty days and forty nights of meditation. Here is why he became a hermit for a while. "The Hermit," in Crowley's mysterious world of tarot, represented for him removal from the outside world, giving him total introversion into the inner self, accessing his deep inner voice and caring for the inner self while seeking self-realization.

A view in Hudson's River of Pakepsey of the Catts-Kille Mountains from Sopos Island between circa 1760 and 1890. *Wikimedia Commons.*

While on the remote island, Crowley had nothing more than a thin plastic tent and a questionable canoe. He used his retreat time to translate ancient Chinese texts like the *Tao Te Ching*. He also wandered out on the island's steep, jagged rock cliffs, using his world-class climbing skills to paint a few curious phrases, including "Do What Thou Wilt" and "Every Man and Woman Is a Star," in red letters.

Neighbors and farmers eventually visited the odd man with the shaved head and brought food and medicinals. One Manhattan woman's cache of brandy and absinthe was so heavy it nearly sank Crowley's meager canoe. Her stay on the island (along with other female visitors) suggests that while Crowley may have been retreating from life, fasting and practicing yogic breathing, he perhaps had not exiled himself from sex, which he said he used as an "elixir of mortality." As a result of his retreat, Crowley believed he had achieved *Siddhi* (enlightenment) and the ability to access past lives, as well as what he called "magical memory."

On the island, Crowley said he had visions of what might be his former lifetimes in which he was a third-century Taoist master and other life memories bubbling up from his unconscious mind. Toward the end of his stay, he said he had an experience that revealed to him "the whole of the Chinese wisdom…its freedom in an utterly fascinating and appalling sense."

Before Crowley came to America and camped on Esopus Island, he was the founder of a scandalous cult called *Magick*, which got him kicked out of England and France in 1929. Crowley, a self-proclaimed high priest of the devil worshippers, then went about traveling the world, calling himself the "Beast of the Apocalypse" and claiming to have hypnotic powers.

Born Edward Alexander Crowley in Leamington Spa, Warwickshire, on October 12, 1875, Crowley's parents were devout Plymouth Brethren, English sectarians who believed themselves to be the only true Christians. Being unusually intelligent and having a broad imagination, as a young boy, Crowley acquired an interest in exploring the soul and the study of black magic, which Aleister preferred to spell *magick*. He delved into the Black Mass, the Cabbala, the teachings of the Oriental sages and the occult in general. After inheriting his family's fortune amassed by selling beer and running alehouses, he enrolled at Trinity College, Cambridge, in 1895, to study moral science, though he later switched to English literature. During this time, he adopted the name Aleister. It was during those academic years that Crowley began renouncing and even rebelling against his Christian background.

After college, he went rock climbing, wrote poetry and kept several mistresses. He also used his time and wealth to search for God. During his questioning period, he believed that he was contacted by his holy guardian angel, an entity known as *Aiwass*. While staying in Egypt in 1904, he also claimed that he received a text known as *The Book of the Law* from what he believed was a divine source—around which he would come to develop his new philosophy of *Thelema*.

Widely seen as his most important work was *The Book of the Law* (1904), the central text of the philosophy of Thelema. Crowley claimed that he himself was not its writer but merely its scribe for the angelic spirit Aiwass. This was just one of many books that Crowley said he channeled from a spiritual being, which collectively came to be termed *The Holy Books of Thelema*.

Crowley was definitely eccentric from the start. In an almost theatrical display, Crowley was fond of wearing flamboyant outfits and traveling extensively until his money ran out and he was forced to live in tenement houses in London. It was there that he wrote his life's story in six volumes called *Confessions*. Only two of the six volumes were ever published. The extremely well-written book described Crowley's mystic mission.

On March 5, 1887, his father died of tongue cancer. This was a turning point in Crowley's life, after which he then began to describe his childhood in the first person in his *Confessions*.

Aleister Crowley in the garments of the Ordo Templi orientis, 1916. *Wikimedia Commons*.

With his mountain of inherited money resulting from his father's passing, Aleister was able to indulge his passions. He became an influential member of the esoteric Hermetic Order of the Golden Dawn after befriending the order's leader, Samuel Liddell MacGregor Mathers.

The Aleister Crowley Foundation Facebook page, which has over twenty-three thousand followers, claims that Aleister Crowley was initiated in the Hermetic Order of the Golden Dawn on November 18, 1898.

It was the influence of the Hermetic Order of the Golden Dawn that shaped Aleister Crowley's life. Once exposed to its Qabalistic system of grades and philosophy, its magical practices and ceremonies, he was never the same.

Aleister Crowley spent much of World War I in New York City, and it was widely speculated that he was acting as an agent of British intelligence. In 1914, Crowley took pleasure excursions out of New York City to Lake Pasquaney in New Hampshire and out to the tip of Long Island. He was dead broke most of the time and wandered around writing an astrology book with astrologer Evangeline Adams that was never printed. He also sold articles to magazines like *Vanity Fair*.

During the rock-and-roll era in the United Kingdom and United States, several British rock groups adapted their music to the writings of Crowley. The Beatles included him as one of the many figures on the cover sleeve of their 1967 album *Sgt. Pepper's Lonely Hearts Club Band*, where he is situated between images of Sri Yukteswar Giri and Mae West. Jimmy Page, the guitarist and co-founder of 1970s rock band Led Zeppelin, had a more intent interest in Crowley. Page was fascinated by Crowley and owned some of his clothing, manuscripts and ritual objects, and during the 1970s, he bought Crowley's home, Boleskine House, which also appears in the band's movie *The Song Remains the Same*.

One of the strangest modern-day connections to Crowley was David Berkowitz, the 1970s *Son of Sam* murderer. He said in several 1981 letters sent to a *Herald Statesman* reporter that when the murders were committed, he and others were cult members in Yonkers. According to Berkowitz, the murderous Yonkers cult to which he says he and his accomplice, John Carr, belonged included both male and female members. The group, Berkowitz said, practiced a variety of rituals and followed the teachings of occultist Aleister Crowley, as well as ancient Druidism, the Order of the Golden Dawn and the Basque witches of Spain.

Aleister Crowley died in a Hastings boardinghouse in the United Kingdom on December, 1, 1947, at the age of seventy-two. According to

one biographer, the cause of death was a respiratory infection. He had become addicted to heroin after being prescribed morphine for his asthma and bronchitis many years earlier. Strangely, Crowley and his last attending physician died within twenty-four hours of each other; newspapers would claim, in differing accounts, that Dr. Thomson had refused to continue his opiate prescription and that Crowley had put a curse on him.

Many years after leaving the Hudson Valley's Esopus Island, the story of Crowley's strange encampment lingers among the long lost land of the Lenape Indians.

Today, Esopus Island is still uninhabited. What's different is it is now open to the public as part of the Margaret Lewis Norrie State Park and is only reachable by boat. Gone is the mystical figure of Aleister Crowley. Today you may just run into a few Boy Scouts or a couple of oddball campers taking advantage of the outdoor amenities and an opportunity to follow in the footsteps of the infamous occultist.

Krazy Kaaterskill Falls

Kaaterskill is a rare two-stage waterfall. It is located on the north side of Kaaterskill Clove in the town of Hunter in the Catskill Mountains between Haines Falls and Palenville, nearby hamlets. Together, the two cascades are 260 feet high, making it one of the highest waterfalls in New York State. The name probably came from seventeenth-century colonists who encountered bobcats or mountain lions and added the word *kill*, which in Dutch means "stream."

There are many legends surrounding the famous Kaaterskill Falls that cling to breathtaking hills deep in the wilds of New York's Catskill Mountains. The fantastic waterfall is a strange and mysterious natural wonder and a site that virtually spawned the American travel industry. It is also considered one of the nation's most haunted regions, brimming with aboriginal tales.

Despite the stories and tales, Kaaterskill's spectacular scenery has attracted everyone from Mohicans to Dutch explorers, Revolutionary War soldiers to pirates and painters to presidents alike. And it lured artists like Thomas Cole and many great writers, from Herman Melville to Washington Irving, each believing Kaaterskill Falls to be one of the most inspirational places in the world.

Since steamboats chugged up the Hudson River and trains traversed tracks, the Catskills and the Kaaterskill Falls have been an allure for people longing to escape the oppressive heat of New York City. For thousands of visitors, the Catskill Mountains were and still are an oasis, a refuge filled with fresh air, clean water and glorious scenery. But these awe-inspiring

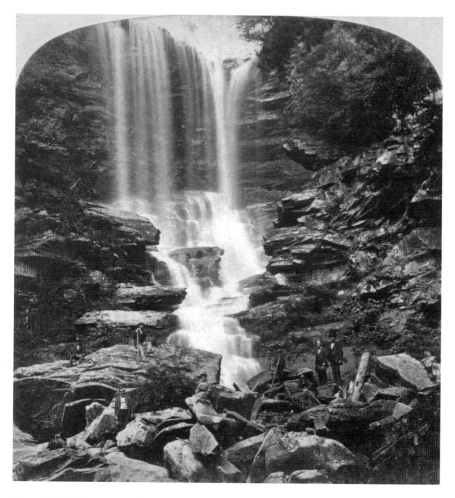

Kaaterskill Falls stereotype by Marion Carson, 1860. *Library of Congress.*

mountains, these giants of the earth with their wonder and vastness made famous by the fictional Rip Van Winkle, are more—much more.

Beyond the exquisite pastoral scenes and the mighty gorges are dark tales of fear of the Kaaterskill Falls' strange summit, where an unusual number of deaths have occurred.

Perhaps the crazy part of the Kaaterskill Falls begins with the Catskill Indians, a rather quiet branch of the Mohicans, and their arch enemies, the Mohawks, who were fierce and unrelenting warriors. The trouble between the two tribes seems to have centered on the Mohawks competing with the Mohicans for the Catskill hunting ground.

There is a story about a Catskill chief who wandered into the woods and fell upon a tiny white-haired maiden in the forest beneath a downed tree. He was taken by her soft blue eyes and incredible blonde hair, and he believed the girl was a gift from the *Manitou*, the Great Spirit. He treated her like a fine jewel, keeping her safe, as she might be sent from another world—a goddess who must be cherished.

As an offering to the gods, the Indians led the maiden deep into a secret grove in the woods, in the hopes that the *Manitou*, their name for the Great Spirit, would approve of the young girl and bring them favor.

While in the woods, the young girl was visited by a mysterious guide who showed her the most beautiful parts of the forest. The guide was a young man who gathered wildflowers for her, making them into a soft bed for her to sleep on. When the Indian chief and tribesmen came back to get the young maiden, they found her in a state of euphoria and were convinced she had been visited by *Manitou*.

These visits to the forest went on year after year, until one day the maiden fell in love with the young man, making it truly difficult for her to leave. The next time her beautiful escort came to get her, they ventured farther into the forest than they had ever traveled before. As a token of his admiration, the youth climbed deep into a rocky ravine to retrieve a handful of harebells, a rare wildflower that he wanted to give to his fair maid who was waiting for him at the top.

Then, quite suddenly, she saw her guide look up to where she was standing. His face looked alarmed. It was then that she heard a cracking twig. What came next was truly ghastly. A terrible war cry bellowed out behind her. She knew instinctively that the enemy Mohawks were near and instantly fled through the forest, with their threatening shouts pursuing her every step. Her heart raced, and though she ran with perhaps divine quickness, the enemy soon came into sight. Just then, the maiden found herself at the precipice of the great Kaaterskill Vale with the deadly Mohawks just a few yards away. All at once, the beautiful maid jumped from the rock into the deep chasm of the fall below.

The legend reveals that as she sprang from the dry rock, water began to flow. The awestruck Indians leaned over the falls and saw the beautiful young Indian maiden dressed in pure-white clothes standing in the midst of the furiously flowing foamy waters of Kaaterskill Falls. She then miraculously disappeared into the arms, they believed, of the Great Spirit, Manitou.

Since that time, many visitors to Kaatersklll Falls believe that the young maid has reappeared. In 1883, the *Windham Journal* reported, "It would

be useless to deny that we were for a moment startled by this apparition of a pale figure in the very center of the Kaaterskill Falls. The hush of twilight, intensified rather disturbing by the sound of falling waters; the deepening shadows in silent ravine and cleft; the thrilling tones of our friend who so mysteriously announced the 'Maid,' all combined to produce a weird and uncanny atmosphere which hung about the gleaming girl-form like a mist."

And the famous poet William Cullen Bryant wrote a poem titled "Catterskill Falls," perhaps as a tribute to the fallen maiden:

> *'Tis only the torrent tumbling o'er,*
> *In the midst of those glassy walls,*
> *Gushing, and plunging, and beating the floor*
> *Of the rocky basin in which it falls.*
> *'Tis only the torrent—but why that start?*
> *Why gazes the youth with a throbbing heart?*

Despite many attempts to curb the kraziness, death continued to come to Kaaterskill. The first hiking trail was built at the falls in 1967 and improved and rerouted several times after. With tens of thousands of people climbing the slippery rocks to the top to glimpse the ravine and gaze overlooking the falling waters, something tragic is bound to happen every once in a while. In 2016 alone, five people had fatal falls.

As the saying goes, there may be "something in the water." With the fall's enticing views and treacherous cliffs, it is the obvious recipe for disasters. The Kaaterskill Hotel, the beautiful resort built on the top of the famous falls, was not so obvious.

In 1924, the well-loved travel destination burned to the ground, totally destroyed by a blaze so enormous it could be seen from every town below. Miraculously, the fire occurred after Labor Day, and no deaths were reported. Before that awful tragedy, the Kaaterskill Hotel was wildly popular, but the venue was built under strange circumstances. A man by the name of George Harding, a wealthy businessman from Philadelphia, was reportedly miffed one day when at an area hotel his ailing wife ordered fried chicken for breakfast and was refused by the chef. Angered at the establishment's owner for refusing her unique choice of morning entrée, Harding vowed on the spot to come back someday and build his own hotel where chicken could be consumed at all hours of the day. In 1882, he made good on his promise and erected the Kaaterskill Hotel at the very top of the falls. From the start,

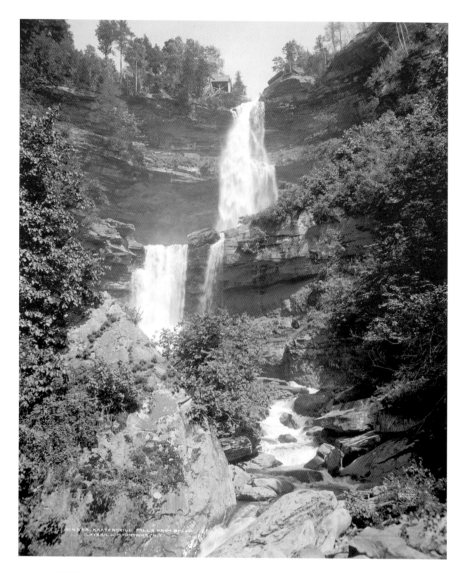

Kaaterskill Falls. *Library of Congress.*

the Kaaterskill Hotel was the source of strange stories like the legend of the Catskill Gnomes.

Long ago, the Mohegan Indians spoke of a hidden place, an amphitheater behind the grand hotel. The natives reported seeing people there working in metals. In Charles Skinner's book *Myths and Legends of Our Land*, he claimed these strange people had small squinty eyes like a pig's and bushy beards and

their work sent up great plumes of smoke, creating a haze in the summer Catskill skies.

The story explains that under a great, clear full moon, it was their practice to gather "on the edge of a precipice above the hollow and dance and caper until the night was nigh worn away." Skinner also described how these little people made their own liquor that could shrink the body and swell the head of anyone who drank it. Henry Hudson himself wrote in his journal of meeting these unusual little people and being invited to partake of the homemade liquor: "The crew went away, shrunken and distorted by the magic distillation."

But how could this wondrous place—romanticized in Thomas Cole's Hudson River School paintings and lauded as far back as the early 1800s as the ultimate travel destination—be anything but beatific? Perhaps there's one last explanation in a tiny plaque that is nearly hidden halfway up the waterfall hike. It is engraved with the date 1868 and pays homage to "Vite," the "Bayard of Dogs," who dove to his death from the top of the falls in an attempt to reach his beloved master at the bottom. Apparently, the dog lost sight of his owner as the man descended the rocks to hike down the falls with friends. When the dog's owner suddenly appeared, the brave spaniel leaped off the platform above. The legend has been told and retold that the ghost of the devoted dog returns each year on June 19, howling at midnight.

For one of the most curious locations in New York's Hudson Valley, Kaaterskill Falls certainly tops the list of one of the kraziest places. Be careful climbing.

14

The Lady Hunter of Long Eddy

In 1872, the *New York World* ran an interesting story titled "A Child of Fate." It told the story of the Lobdell family, who lived near Long Eddy in Sullivan County, New York.

Long Eddy was nothing more than a quiet settlement near the Erie Railway made up of lumbermen who earned a living chopping, cutting and hauling trees. Like most settlements in this time in New York State, the area surrounding the log cabins was quite wild. Some people say that the families living in Long Eddy lumber camps were a bit uncivilized as well.

Like many of the families in Long Eddy, the Lobdells didn't have much money. Lucy Lobdell lived in Long Eddy with her mother and father. She was bright and intelligent as a child and went to school, which filled most of her time. When she wasn't studying, however, she explored nature with a kind of reckless abandon.

Her parents found life in this remote area of New York difficult, but Lucy loved roaming the backwoods. The deep forests intrigued her, and she even dared to accompany the men of the town into the logging camps, something that women never did in the 1800s. Stories of Lucy's strange, adventurous spirit spread throughout the county.

Within a few years, Lucy grew out of her tomboy stage and became a woman. But that didn't stop people's gossiping that she was "as strong as a man, active as a deer and peculiarly handsome."

Lucy was indeed different. She had a strange brown complexion, almost like an Indian, and she cut her dark curly hair short, cropped close to her

The Woodsman, etching by Edward Bannister, 1885. *Library of Congress.*

head. Despite her rather odd gray eyes and her unusual appearance, men both loved and feared her. And why not? Lucy was known to wield an axe like a pro and considered a crack shot with a rifle, better than most men in the region.

With these expert outdoor skills, Lucy ventured out into the deepest part of the woods on hunting and fishing expeditions. Never did she return to her father's cabin without a kill. On one extraordinary hunting trip, Lucy tracked a large panther for days until she finally killed it, taking home its prized skin to make into a lap robe.

Despite her strange appearance and her penchant for hunting, her odd qualities attracted male suitors and she received many offers of marriage from lumberjacks, teamsters (men who drove teams of horses) and sawyers (sawmill workers).

Up until she turned twenty years old, Lucy turned down all of the matrimonial proposals. Then one day, a man a few years older than Lucy came to Long Eddy. His name was Henry Slater, and he was a backwoodsman and a raftsman. It wasn't long before they were married in 1851, and on the wedding tour, the young couple went on a daring raft trip down the Delaware River. When they realized at the start that they were short one man to help paddle the boat, Lucy volunteered to take one of the oars.

Though still newlyweds, technically, one year later, Lucy was deserted by her husband and left with a new baby only a few weeks old. Trying to support herself, her child and her aging parents, Lucy could have gotten desperate, but instead, she got creative.

Dressed like a man, Lucy devoted her time to hunting and trapping, and for many years, she roamed the forests of Wayne and Pike Counties, Pennsylvania, and Sullivan and Delaware Counties, New York. Her disguise was not foolproof, however, and soon Lucy was known as the "Lady Hunter of Long Eddy."

Living in the woods, sometimes for months without ever emerging, Lucy made her way across the rich pine forests, staying in makeshift cabins. In 1856, Lucy surprised the world by announcing that she had written and published a history of her hunting life, *Narrative of Lucy Ann Lobdell, the Female Hunter of Delaware and Sullivan Counties, N.Y.* The autobiographical contents she included turned out to be quite stunning. In the book, Lucy stated that she had killed some 373 deer, 15 bears, 20 catamounts and innumerable small game, including foxes. She wrote how she had trapped hundreds of mink and otter. The entire tale was truly remarkable, but there was more.

Her book contained a fascinating account of a strange adventure she had in 1854 with a large bear near the head of the Mongaup Creek in Sullivan County. She described how she followed it for a long time, waiting for the exact right shot. As it climbed a tree, she shot it, and it dropped to the ground. Though Lucy was certain it was dead, she was awestruck when the bear got to its feet and rushed at her. She ran, loading her gun as she tried to get away by climbing a tree. Lucy wrote in her book that the bear got so close she could see its jaws wide open. She was able to get the shot off before losing consciousness. The next thing she said she remembered was standing on the ground with the bear at her feet. It was her thought that she had somehow fainted after firing.

For eight long years, Lucy lived like a woodsman, a pioneer. In 1860, she realized that she had had enough isolation and returned to her family and her daughter, who was no longer a child but a girl of eight years old.

Lucy found it very difficult to socialize and readjust to motherhood, and her daughter was often seen begging at houses in the village. Though Lucy put her men's clothing away, she never really regained herself, and finally, she and her daughter ended up in the Delaware County Poor House. Within a few short years, Lucy's daughter was removed from the poor house and given to the family of Daniel Fortman, taking the name of Mary Fortman. Clearly, the poor child was greatly affected by her mother's life choices.

In the poor house, Lucy met Mrs. Wright (Marie Louise Perry), a young jilted wife with no money and no home. The two formed a close friendship, and when it came time for Mrs. Wright to leave, she refused to go without Lucy. The authorities disliked that the two were so attached to each other, so they allowed Mrs. Wright to stay.

After two more years in the dreadful institution, the two women escaped, running off together on a summer's night in 1867 to Jackson Township in Monroe County, Pennsylvania. When they left the poor house, they were

two women, but when they reappeared in Pennsylvania they were a couple, a man and a woman, claiming to be husband and wife.

By this time, Lucy's face was weathered and wrinkled from years of exposure outdoors and her once dark brown curls now boasted a shocking streak of white. She insisted on carrying her rifle wherever she went, and her long-eared hunting hound remained by her side. Lucy's companion, by comparison, had straight dark brown hair that hung down her back. Her clothing was shabby but clearly that of a woman. In her new incarnation, Lucy claimed to be a preacher, and to make money, her companion sang hymns. When that scheme failed, the couple resorted to living in the woods, in caves and cabins and old hunting lodges, foraging for roots and berries and whatever Lucy could kill with her rifle.

After months in the forest, the pair suddenly reappeared in the village of Canadensis with two young bears, one guided by Lucy and the other following Mrs. Wright. They never explained how they captured the bears

The Long Eddy Erie Railroad station on the main line in Long Eddy, New York, 1909. *Wikimedia Commons.*

and guided them through the wilderness, but they refused all of the financial offers that the amazing bears brought. The very next day, the couple and their catch disappeared.

For better or for worse, the couple reappeared, and once again they were thrown in jail, this time as vagrants. Soon after their release, they announced their names to be the Reverend and Mrs. Joseph Israel Lobdell.

The truth about Lucy's gender would not remain a secret long. After a brief visit in the county jail again, Lucy's identity was revealed, and people from all over came to see a woman who had, for nearly three years, successfully sustained the character of a man.

With nowhere else to go, the couple finally returned to Lucy's parents' home in Long Eddy, having received word that her mother was dying.

At this point, the history is blurred. There is a fragment of information that suggests that Lucy's daughter tried to find her mother, and there are some accounts that say that Lucy suffered a nervous breakdown and eventually died in the wilderness with Mrs. Wright by her side.

In 1850, a newspaper offered a rather different story, announcing Lucy Ann Slater's death in the *Tri-States Union*. This account reported that Lucy died in a New York State Insane Asylum at age fifty.

Though the details of her demise are not very clear (a *New York Times* story reported that a "Joseph Lobdell" died in 1912), her life story was remarkable. Lucy Lobdell will be remembered as the famous Lady Hunter of Long Eddy.

III

UPPER HUDSON VALLEY

DUTCHESS, GREENE, ALBANY AND COLUMBIA COUNTIES

Dutch Schultz

Gangster Bootlegger

Drinking was a dirty business back in the 1930s. Liquor and spirits were outlawed in New York due to harsh Prohibition laws restricting the sale and consumption of most types of alcohol. These prohibitive restrictions were created in large part by the Anti-Saloon League, which was moved to the forefront by societal pressures enacted by the Woman's Christian Temperance Union, which lobbied to forbid the consumption of alcohol. The laws were also supported heavily by the Protestant Church and the temperance movement, which dates all the way back to England in the early 1800s. These factions worked furiously to steamroll the alcohol industry in New York, but with so many people making so much money selling alcohol, there was naturally resistance. When it became impossible to sell alcohol legally, risky bootlegging businesses flourished in farm towns outside of New York City, where there was little notice of bad guys and booze.

The town of Pine Plains became infamous when notorious gangster Dutch Schultz operated one of the largest illegal underground distilleries in the country.

Dutch Schultz was born Arthur Felgenheimer on August 6, 1902, in the South Bronx. It was a tough place, and poor German Jewish immigrant kids like Arthur were everywhere trying to survive. Life was rough for Arthur, and things got even worse after his father abandoned him and his family.

To make money, Arthur became a petty thief. Around the time he turned seventeen, he was sent to jail for the first time. New York prisons have been known to have a quick and long-lasting effect on the inmates, and it didn't

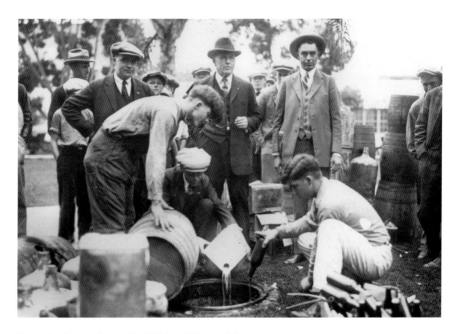

Dumping booze during Prohibition. *Library of Congress.*

take long before Arthur was a true tough guy. When he was finally released, he was transformed with a new attitude and a new name. He went into prison as Arthur and came out as Dutch Schultz. When in prison, Arthur said he lifted his new name, Dutch, from a famous former street fighting criminal from the 1800s who was part of the Frog Hollow Gang and well known for his fierce temper.

Dutch continued to live a life of crime for many years, but when he could, he would take an honest job. Between robberies and heists, Dutch would drive a truck for a living with his good friend Joey Noe. Not long after partnering with his buddy, Dutch was hired by a gang of bootleggers who needed him to deliver kegs of beer around the city. Realizing the kind of profits that could be made (three dollars for a keg of beer sold to distributors for nine dollars and then to an illegal bar, or speak-easy, for nineteen), Dutch and his friend started bypassing the bootleggers and began their own beer buying and distribution business, which entailed purchasing beer from makers outside of New York City to avoid having to share their profits with other established gangsters.

In the 1920s and '30s, New York's rival gangs fought one another bitterly for business, to the extent they would carry machine guns in their trucks, torch rival establishments, hang men from hooks and hold them hostage for

ransom if necessary. Despite being a rather small man, Dutch was brutally aggressive and relentlessly competitive.

Dutch was determined to make a name and make money, and it wasn't long before "The Dutchman" and his friend were controlling most of the speak-easy clubs in the Bronx. Unfortunately for Dutch, their success would end abruptly when Noe was gunned down in the street, murdered in cold blood. Dutch took the death hard. The only good thing that came out of the tragedy was that Dutch inherited his friend's half of the business, which allowed him to become the biggest bootlegger in Manhattan.

When small-time bootleggers rose to the top, people took notice. Dutch's new status caught the attention of mob boss Lucky Luciano. In 1929, the two men had a meeting. Their talk must have gone well, because soon after, Dutch and Luciano formed a crime syndicate together, leading to many years of successful New York bootlegging, not to mention an awful lot of bloodshed.

After a while, the years of crime, murder and mayhem weighed heavily on Shultz like a full case of whiskey. Maybe to get away from it all, in 1932, Dutch took a substantial portion of his wealth to start a new bootlegging operation that would secretly add significantly to his income. Under the auspices of running a turkey farm, Schultz set up a secret spirits facility in Pine Plains, New York.

Dutch kept his new business out of the public's knowledge by creating an intricate underground system of sophisticated hillside bunkers, hidden hallways, concealed pipes and even a camouflaged bunkhouse on the farm site in Upstate New York. On the surface, the bootlegging operation looked legit, with turkey coops and hay barns, farm equipment and the appropriate accouterments to give the impression that nothing out of the ordinary was going on.

But as the business of bootlegging became more and more successful, the operation grew entirely too big to keep under cover, even in a sleepy little place like Pine Plains in the 1930s. Perhaps it was the frequent sugar deliveries or the heavy truck traffic that gave the whole thing away, but when the place was finally raided by authorities, police found a huge alcohol production network they could hardly believe.

Some of the workers were arrested on the spot, and the equipment was seized immediately. Ironically, the actual owner of the farm was a retired policeman named Patrick Ryan. After the raid, when the bootlegging was shut down, he quietly returned the moonshine operation back into a quiet turkey farm.

Life for Dutch Schultz after the raid was not so simple. Dutch successfully fled the farm, narrowly missing the police, and hid out at the home of a friend near Saratoga until he was finally arrested.

On November 28, 1934, the *Saratogian* newspaper headline read "Baby Face Nelson Found Dead," but not far under that is a photo of Dutch Schultz's scowling face and a short piece explaining how the gangster gave himself up near Albany. The quote from police commissioner Louis J. Valentine, who apprehended Schultz, read, "My only regret is that he is not being carried into the City of New York in a box."

Dutch Schultz had his day in court soon after. He was tried on racketeering and income tax evasion on over $400,000 in earnings. According to the papers in 1935, at his trial, the "beer baron of the Bronx" tried in vain to reclaim his notorious big black ledger, which apparently provided the key piece of evidence that convicted him.

Before Schultz was sentenced, he was in a bar called the Palace Chophouse at 12 East Park Street in Newark, New Jersey, which he was using as his new headquarters. At 10:15 p.m. on October 23, 1935, Schultz was shot along

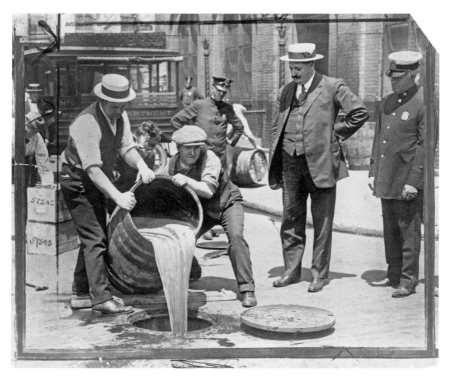

New York City deputy police commissioner John A. Leach (*far right*) watching agents pour liquor into the sewer following a raid during the height of Prohibition. *Library of Congress.*

with his two bodyguards and accountant. Dutch remarkably survived the awful attack and was rushed into surgery at a nearby hospital. The doctors who worked on him said they were unaware that Schultz's assailant had intentionally used rust-coated bullets in an attempt to give Schultz a fatal bloodstream infection (septicemia) should he survive the gunshot. Sadly, Dutch Schultz lingered in agony for a full twenty-two hours. In his delirium, he went in and out of consciousness, speaking to his wife, his mother, a priest, police and hospital staff before dying of peritonitis.

But the story doesn't stop there. It seems that while he was dying, Schultz uttered a string of curious last words in a strange stream-of-consciousness babble, spoken in his hospital bed to police officers who attempted to calm him and question him for useful information. Although the police were unable to extract anything coherent from Schultz, his rambling was fully transcribed by a police stenographer. Here's what he said: "A boy has never wept…nor dashed a thousand kim." But the entire text is much more rambling, for example: "You can play jacks, and girls do that with a soft ball and do tricks with it. Oh, Oh, dog Biscuit, and when he is happy he doesn't get snappy."

One of his last utterances was a reference to "French Canadian bean soup." (French Canadian pea soup is a popular dish that is still produced as canned goods by many food companies.) Schultz's last words inspired a number of writers to devote works related to them. Beat generation author William S. Burroughs published a screenplay in novel form titled *The Last Words of Dutch Schultz* in the early 1970s.

Shortly before his death, fearing that he would be incarcerated for life, Schultz commissioned the construction of a special airtight and waterproof safe, into which he placed $7 million in cash and bonds. Schultz and his then partner in crime Rosencrantz drove the safe to an undisclosed location somewhere in Upstate New York and buried it in the Hudson Valley. At the time of his death, the safe was still interred; as no evidence existed to indicate that either Schultz or Rosencrantz had ever revealed the location of the safe to anyone, the exact place where the safe was buried died with them. Gangland lore held that Schultz's enemies, including Lucky Luciano, spent the remainder of their lives searching for the safe. The safe has never been recovered.

The Curious Case of Oakley Hall III

In 1978, at the precipice of becoming a nationally recognized star in the world of theater, Oakley Hall III silently slipped off the bridge spanning the Schoharie Creek in Lexington, New York. In that split second, he became a strange caricature of his former self. The legend of Oakley on that fateful July night is woven with haunting clues suggesting that Oakley was not alone on the bridge but accompanied by a dark stranger. Questions still circulate asking if he simply slipped, jumped or, worse, was pushed.

Miraculously, somehow, in the silence of the wilderness, Hall survived the fateful fall, but the case has never been settled, and his life was never the same, making Oakley Hall's story ever more curious. He said of that fateful night: "I think I remember that night. I remember, I think; walking across the bridge, which I didn't make it all the way across."

At the time of the accident, Oakley Hall was producing and directing his world-class original plays at the Lexington Conservatory Theater Company, which he founded in the remote reaches of the Catskills. With a brilliantly creative mind and a charismatic personality, Hall drew people to Lexington like the Pied Piper lured little children out of their homes. Gathering an ambitious and dedicated menagerie of hippies, actors, groupies and production people, Hall transformed a run-down former Catskill camp into a thriving creative commune. His plays *Grinder's Stand* and *Beatrice and the Old Man*, as well as his adaptation of *Frankenstein*, premiered at Lexington.

Many years before Hall's arrival, Lexington, New York, had been known as a lively little resort town in the 1850s. John Lament, Martin Lament and

Lucas Van Valkenburgh all listed themselves as hotelkeepers. The 1856 map shows J.M. Lament at the west end of the hamlet of Lexington with a house labeled simply "Lament" on the highway now designated CR 13 north of the hamlet.

Lexington hotelkeepers followed the trends of resorts farther east in Greene County—especially the successful Catskill Mountain House on the Pine Orchard precipice built in the town of Hunter in 1824—that were attracting hordes of people eager to escape the urban swell of the city. Week in and week out, a wealthy set of summer travelers swarmed the area with a great deal of money and leisure time looking to take part in such activities as easy walks in the woods, carriage rides and rowing in gentle streams amid the romantic and rustic setting of the Catskills.

The Lexington House, on Schoharie Creek, later the home of the Lexington Theater, was built for vacationers in 1883. As resorts go, this particular one was a modest building featuring thirty finely appointed guest rooms. It advertised accommodations for no more than fifty guests, providing a more private setting in contrast to the grand-scale resorts in the Catskills that could host five hundred to one thousand guests at one time.

The Lexington House contained spacious public areas for entertainment and included a lovely ballroom. There were actually six buildings on the property. Aside from the main house, there was an icehouse, a wagon house, a river theater/skating rink, a small shed and a long open shed. Gas lighting and specialty fireproof framing placed between the interior wall allowed the owners to tout the house as having modern conveniences. In 1887, the river theater opened to give more space for socializing in the main house. It was also used as a skating rink in the winter months.

Across the way from the Lexington House was the Lexington Hotel. Opened in 1878, it was a cheaper alternative to the bigger resort. It still survives today but has been abandoned for quite some time. The Lexington House saw its final decline in the 1940s, and in the 1950s, it became a music and art camp for children. In the 1970s, it was transformed into the Lexington Theater.

As the creative director of the Lexington Conservatory Theater, Hall adapted his natural charm to molding his band of merry men into a world-class experimental theater group. His intuitive leadership and creative abilities could have been a heavenly gift, but it's more likely that he simply came from good genes. With an IQ of 180, he was, in plain terms, a wild, genius writer. Early on, people around him predicted he was destined to become one of the country's greatest playwrights.

He was born in May 1950 into an ultra-creative family. His mother, Barbara Hall, was a photographer, and his father, Oakley Hall II, a novelist and professor at UC Berkeley in northern California. Oakley Hall Sr. wrote thirty books, novels and mysteries and two on the craft of novel writing. His most famous work began the day he realized that his grandmother lived next door to the biographer of Wyatt Earp. Oakley Hall Sr.'s most acclaimed book was *Warlock*, which featured fast-shooting cowboys in Tombstone, Arizona, in the 1880s. The western novel was a finalist for the 1958 Pulitzer Prize, and it was eventually made into a movie starring Henry Fonda. Later, he wrote *The Downhill Racers*, also made into a movie starring Robert Redford in 1969.

The younger Oakley Hall was called "Tad" by his friends and family. As he was growing up in California, Tad absorbed himself in books, plays and poetry and became somewhat of a romantic hero at UC Irvine, where he was loved by everyone. Tad was also brooding, moody and obsessed with grotesque mythological stories. People who spent time with Tad said he was intense, complex and difficult. At UC Irvine in the 1960s, he was a super student studying theater, writing plays, acting and directing. Some commented that he was competing with his father, who was already an accomplished writer. He also developed a strange, lifelong fascination with French playwright Alfred Jarry. As a college undergraduate, no one could have predicted that his life might read like a Greek drama with a fateful all-or-nothing ending.

After college, Tad found his way to New York City, where he dove into the theater scene. He translated all three of Alfred Jarry's *Ubu* plays, and he staged *Ubu Roi* in Manhattan. His big break eventually arrived when his play *Mike Fink* was optioned by Joseph Papp of the Public Theatre. This was his ticket to stardom.

In 1976, Tad ventured up to the wilds of Upstate New York to construct a theater where he could freely write and produce his own unique style of theater. It was there in Lexington that he and co-founder Bruce Bouchard and a few fellow actors resurrected the old Lexington House, rebuilding the decaying resort by hand. For three years, the theater thrived, attracting patrons from New York City who were enthralled with Tad's unconventional productions like *A Streetcar Named Desire* and his vintage playhouse tucked away in the Catskill Mountains.

At the time of Hall's accident, he was in the midst of completing a rewrite of *Grinder's Stand*, a gripping drama that recounts the unusual circumstances surrounding the final days and death of Meriwether Lewis, half of the

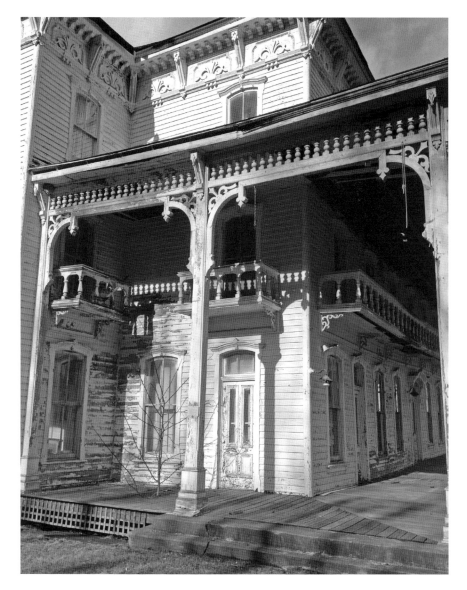

Lexington Conservatory Theater. *Wikimedia Commons*.

famous Lewis and Clark duo who journeyed eight thousand miles on a transcontinental trek across America in the early 1800s. It was at that moment that his life turned upside down, literally.

Tad was only twenty-eight years old when the tragic accident occurred. On a foggy July night in 1978, walking outdoors after a night of partying,

Tad slipped and plunged off the bridge spanning the Schoharie Creek. A young man who had been staying with the theater group and walking with Tad that night rushed into the main building to report that Tad had been hurt. Rumors floated that Tad had been out drinking with this mysterious man, yet no one knew who he was.

Tad was discovered by his friends lying on the rocks beneath the bridge, barely alive. His head bore the brunt of the fall, and his face was a jumbled mess of blood, broken bones and torn flesh. At first sight, no one believed he could have possibly survived. His friends accompanied him in the ambulance on the way to Albany. In the ambulance, the attending doctor said Tad stopped breathing and had to be revived at least once.

The result of Tad's fall was a traumatic brain injury that should have completely robbed him of his ability to think, create, reason and live out a normal life performing basic tasks, but it didn't. Though he spent months in the hospital and years wandering through life attempting to recover what he once had, his creativity found a way to shine through. In spite of his condition, *Grinder's Stand* premiered at the Lexington Theater with great fanfare in 1979.

In 2015, the play was revived at the Bridge Street Theater in Catskill, New York, where the players of the former Lexington Theater congregated after the original playhouse folded in the late 1970s.

Oakley Hall III was a man who was clearly possessed by the theater, unapologetic about his desire for unleashed self-expression. He also had a tenacious grip on life. Though this type of traumatic injury surely should have extinguished his creative flame, Tad Hall continued to write, produce and direct. While living in Nevada City, California, he successfully launched another production of *Grinder's Stand* and completed his brilliant book intertwining the life of two geniuses in a fictional autobiography of Alfred Jarry called *Jarry and Me*.

Hall claimed that he came to write this book purely by chance. He said:

> *Alfred Jarry was an avant-garde French playwright, artist, and raconteur, best known for his almost-drawing-style farces, featuring Ubu. He died in 1907. Of too much absinthe. In Paris. I was, kind of, after my Accident, looking for this autobiography, and I found it at a Used Stuff Sale, maybe my stuff, in upstate New York. It was in a sack along with a loose-leaf, typewritten translation of Jean Anouilh's* Becket. *It was in a dark folder, and said JARR across it. So. Here is his Autobiography, and some of Mine.*

In 2004, director Bill Rose produced a remarkable documentary on Oakley Hall III's life called *The Loss of Nameless Things*. This emotional film tells the story of the Lexington Theater Company, Oakley Hall's bizarre transformation and his continuing contributions to theater and literature. Hall appears in the film along with his former Lexington Theater Company members, who recount their strange and curious time in the Catskill Mountains.

Oakley Hall III died at age sixty of a heart attack on February 13, 2011.

Cursed Ground in Millbrook

For anyone searching for the perfect location for a luxury getaway, the rolling pastures and stately mansions of Millbrook might have looked like a golden opportunity. It was perfect for New York City publisher and hotel developer H.J. Davison Jr. and his designer, James E. Ware, who set out to build a new two-hundred-room luxury resort. The businessmen were convinced that the gorgeous piece of property they stumbled upon was the ideal site for tourists who were looking to escape the heat of New York City summers. Just two hours away from New York, it was a prime destination for anyone seeking a fabulous country getaway; therefore, investors scooped up the twenty-two-acre parcel in 1890.

The developers got to work right away building an East Coast resort that equaled that of Newport, Rhode Island, and would attract socially prominent travelers. From the start, the owner insisted on using the finest and most expensive materials, including fieldstone from nearby Mabettsville, carefully selected wood and stone. With this vision of paradise in mind, the architect, James E. Ware, dreamed an elaborate Victorian Queen Anne–style resort boasting of hundreds of rooms, five stories, a basement and a sub-basement. The hotel, when finished, would be equipped with an extra-large living room with a grand fireplace, a glorious ballroom, a fully outfitted kitchen and a spacious dining room, all with the most wondrous country views.

Upon its completion, Davidson filled the library with amazing books, art he and his wife had collected on their European excursions and keepsakes from around the world. His unique hotel was a retreat for customers who

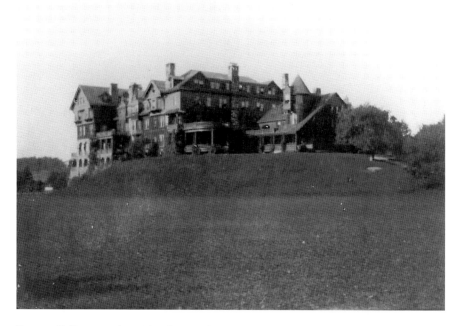

Bennett College exterior, 1907. *Courtesy of Millbrook Historical Society Archives.*

could appreciate the fine features he installed, like beautifully carved wooden pillars, expansive balconies and small alcoves where guests could nap or read. The Nuremberg room featured furniture and paintings from Nuremberg, Germany.

They decided they would call it Halcyon Hall, and the owners touted it as the Hotel of the World. The name of the hotel, Halcyon, alludes to a place of pleasant pleasure.

Halcyon Hall opened in grand style in 1893 and was touted as the social event of the season. The Russian Royal Court Orchestra was hired to play music in the ballroom while ladies dressed in elaborate gowns danced with men in tuxedos.

Guests came to stay at the resort from all over. They flocked to make reservations and to enjoy magnificent meals in the dining room, which featured soaring crystal chandeliers looming overhead. Many took advantage of the extensive riding stables in the area, where horses could be rented for the day or a guest's personally owned horse transported and boarded for the week. There were nearby golf courses, and guests often simply opted to spend a sunny afternoon strolling the peaceful grounds at Halcyon. The

idyllic resort was a resounding success—that is, until the Spanish-American War broke out in 1898. Though the beloved Teddy Roosevelt successfully led the brave Rough Riders up the hill at San Juan in Cuba and reversed the war in favor of the United States, a terrible financial strain took hold in America, bringing with it a tide of poverty and a great recession.

Despite the grandeur, fewer and fewer guests visited Halcyon Hall, and many of the previous guests were seeking out places like the seashore on Long Island. The hotel struggled for a while, sputtering until it finally closed in 1901. It then stood vacant for eight long years until another buyer was found. With a huge amount of money invested, the owners desperately searched for a way out of the financial loss.

In 1907, May Friend Bennett purchased the hotel and converted it into the new home for the Bennett School for Girls (later named just Bennett College). In 1890, she had founded the private school in Irvington, New York, and after seventeen years running the school successfully, Bennett needed more and larger buildings.

Bennett's school became known for its high standards and quality education, and though the resort owners failed to attract wealth and prestige, May succeeded in enticing some of the most prominent American families to send their young ladies to benefit from the sought-after curriculum, which included fashion, interior design, music, dance, drama and languages, as well as tennis and horseback riding.

The women enrolled in the expensive prep school often took a five- to six-year course of study: four years of high school and one to two years of higher study.

As the luxury resort turned into an institution of learning, it underwent a number of changes. When Bennett took it over, Halcyon Hall was in a terrible state of disrepair. By 1908, Bennett had opened her school, complete with a riding academy. She employed the very best teachers, who taught the girls refined living by instructing them in drama, languages, dance and a long list of other skills that wealthy upper-class young women would need to know. In early 1910, the senior class was treated to an elaborate trip to Italy for a semester, where they could showcase their skills amid the many museums and Italian treasures.

In 1926, there were even more additions to the school, as it segued into Bennett Junior College. A northern service wing that formed part of the courtyard was demolished and replaced with the Gage Hall. The new wing had originally held dormitory rooms but was converted into classrooms, offices and other facilities in later years. By the 1950s, the stucco Alumnae

Bennett College dining room. *Courtesy of Millbrook Historical Society Archives.*

Hall had been added as a dormitory. In 1956, the Ella Buffington Library was built out of the east wall of Gage Hall.

Though Bennett finally retired, Bennett College did well for many years but found itself struggling to survive in the 1970s as the popularity of coeducation schools steadily grew. The final blow might have come when the new directors upgraded the school to a four-year college. The change apparently left the institution with irreversible financial troubles.

When the directors' attempt to merge with nearby Briarcliff Manor failed, Bennett College entered bankruptcy in 1977. The school was closed for good one year later, and many school artifacts, including the entire library, were moved to the Millbrook Free Library.

Since then, the property seems to have experienced a slow and painful demise. Despite several attempts to redevelop the property, each has mysteriously failed. Water pipes burst when the unused building's heat was turned off, causing floodwaters to cascade through the elegant hallways—taking expensive wallpaper, tapestry carpets and gilded copper finishes with it. When the sewer system backed up, a wretched

stench filled the premises. Over years of neglect, the roofs have given way, allowing nature to take hold of the once elegant palace. Wind has rotted the windowsills, and vines have strangled carved staircases. The once astonishing resort resembles a shipwreck stranded at the bottom of the sea.

Without a single soul wanting to invest in the now dreadful property, one must wonder if Halcyon Hall sits on cursed ground.

With the decaying buildings causing public outrage, a group of local residents in the 1980s managed to have the title acquired by a savings bank subsidiary. When the bank went out of business in 1991, its assets, including Bennett College, were seized by the FDIC. At that time, an agreement was reached to place Halcyon Hall in the National Register of Historic Places, and it was in 1993.

In 2014, the Bennett College campus was sold by Bennett Acquisitions to the Thorne Farm LLC and the Millbrook Tribute Garden Foundation. The foundation said the acquisition was made to prevent development from falling into the wrong hands.

There was also an agreement that the almost thirty-acre parcel would be partially converted to a park as an addendum of the nearby Tribute Gardens in the village.

Local newspapers printed threatening headlines that Halcyon Hall was scheduled to be demolished "in a safe manner, with the hopes of keeping the stonework intact and create a park-like atmosphere," according to foundation trustee George Whalen III. And later reports said that eight separate parcels were to be subsequently developed in accordance with a "long-term plan that makes sense for the community." After consultation with planning professionals and the input of Millbrook residents, there was consensus that a demolition firm should be hired to finally demolish Bennett College, along with the school's Harkaway Theater (originally the hotel's stable in 1893). The two cottages, Hale and Hillside House, would also be leveled. The only piece likely to be saved would be the 1920s Tudor chapel.

As of 2016, however, Bennett College, the former Halcyon Hall, had become one of the most talked about abandoned sites in New York State, with rumors of hauntings and ghost sightings filling the airwaves and the Internet. To date, it continues to crumble, and there are no solid plans to restore it or remove it.

Despite the bad luck that somehow surrounded the campus, Bennett College was successful in educating scores of successful graduates. One

famous graduate, Mercedes Matter (1913–2001), founded the New York Studio School in Greenwich Village.

Born in New York in 1913, Matter grew up in Philadelphia, New York and Europe. Her father, the American modernist Arthur B. Carles, had studied with Matisse, and her mother, Mercedes de Cordoba, was a model for Edward Steichen.

As a young girl, Mercedes began painting under her father's supervision at age six, and she studied art at Bennett College in Millbrook and then in New York City with Maurice Sterne, Alexander Archipenko and Hans Hofmann.

In the late 1930s, she was an original member of the American Abstract Artists organization and worked for the federal Works Progress Administration, assisting Fernand Léger on his mural for the French Line passenger ship company. Léger introduced her to Herbert Matter, the Swiss graphic designer and photographer, whom she married in 1939.

The Matter family was active in the emerging New York art scene and also traveled frequently to Europe. Their closest friends included Jackson Pollock, Lee Krasner, Franz Kline, Philip Guston, Alexander Calder and Willem de Kooning. They were also close to Alberto Giacometti, who was an important artistic role model for Mercedes Matter and a frequent photographic subject for her husband.

Beginning in 1953, Mercedes Matter taught at the Philadelphia College of Art (now University of the Arts), Pratt Institute and New York University. Based on her teaching experiences, she wrote an article for *ARTnews* in 1963 titled "What's Wrong with U.S. Art Schools?" In it, she lamented the phasing out of the extended studio classes required to initiate "that painfully slow education of the senses," which she considered an artist's life work.

The article prompted a group of Pratt students to ask her to form a school based on her ideas, and in 1964, she founded the New York Studio School. Originally located in a loft on Broadway, the school gained almost immediate support from the Kaplan Fund, the Rockefeller Brothers Fund and the Ford Foundation. It granted no degrees, had only studio classes and emphasized drawing from life. Its teachers, chosen by the students, included artists Philip Guston, Bradley Walker Tomlin, Charles Cajori, Louis Finkelstein and Sidney Geist; art historian Meyer Schapiro; and composer Morton Feldman.

The Matters lived on Macdougal Alley, where Herbert had a studio in one of the eight small buildings that had housed what is now the Whitney Museum of American Art. He believed the buildings would make a perfect home for the Studio School and bought them from the Whitney family in 1967.

Mercedes Matter was an artist obsessed. She sometimes spent years on one drawing or a single still life. Along with painting and drawing, she taught art and contributed articles to magazines on such famous artists as Hofmann, Kline and Giacometti. Mercedes Matter died in 2001. Her legacy, perhaps, in part, was growing a garden out of the seeds planted by Bennett College.

18

The Wreck of the Steamship *Swallow*

The *Francis Skiddy*, the *Empire*, the *Sunnyside*, the *City of Troy*, the *Saratoga*, the *Adirondack*, the *Amenia*—these ships were all lost on the Hudson River in the mid-1800s in the waters off the shore of what we know now as the city of Hudson. Though all these ships succumbed to the strange rolling waters of the Hudson, it was the mighty steamship *Swallow*, which sank near Athens on April 7, 1845, that caused the most suffering, the most tragedy and loss. Sadly, when the boat sank, it took forty people down with it.

Many stories have been told of the disastrous night that the *Swallow* met its end. Eyewitnesses watched in horror from nearby restaurants on the dock and from town saloons as the favorite ship somehow crashed into a shallow rock island off the Flats of Athens.

It happened at 8:00 p.m. on a very cold spring evening in April, when snow should not have been an issue, but it suddenly started falling in thick sheets. Then, the *Swallow* hit a tiny rocky island, Noah's Brig, as it was known to men of the river. It took only a few minutes before the bow of the ship was resting on the bottom of the Hudson River, while the stern stayed safely positioned on the rocks.

The blow battered the ship far worse than anyone could have predicted, and when the water rushed up into the ship's boiler room, it ignited an enormous fire that shot vast billows of smoke up into the passenger rooms. The flames were so bright, they lit up the night sky. The fatal blow came to the wreck when the sharp island rocks put a gash in the steamer's side, allowing water to rush in and fill the boat and berths. People on shore

Loss of the steamboat *Swallow* while on a trip from Albany to New York on Monday evening, April 7, 1845, Currier and Ives. *Library of Congress.*

helplessly watched the ship quickly list to one side while the screams of three hundred shocked and terrified passengers filled the frigid night air.

Many of the ship's prominent passengers were instantly cast into the water, and several who had not fallen frantically leaped into the waters, fearing the fire. Women in nightdresses scrambled to stay afloat, and many were swept away by the river's strong current. Those left aboard the ship resorted to holding on for their lives on the forward upper decks. Onlookers said they could see the anguished faces of the passengers and frantic crew not knowing their fate.

Within a short time, the bells of churches on either side of the river were sounding the alarm. Torches appeared on the shore as boats sped to the wounded shipwreck to assist as best as they could. Fellow steamboats *Rochester* and *Express* carefully approached the distressed steamer, and rescue parties set out in rowboats hoping to save as many lives as they could.

Nothing could be done to help the gracious *Swallow*. By morning, there was nothing left but the scarred remains and a trail of luggage, strewn pieces of clothing and bits of the ship's equipment.

On board the *Swallow* were about three hundred people. Ninety-four were rescued by the *Rochester* and about forty by the *Express*. A number of other survivors made it to Albany by way of the *Robert L. Stevens* and the *Utica*.

A firsthand account of a survivor, a Mr. Wyckoff, a member of the New York Assembly, was printed in the *New York Evening Journal* soon after. Wyckoff said he was swept off into the river at the time of the wreck and was immediately "seized by two or three persons who were already struggling in the water." In minutes, he drifted away from the ship and had no other choice but to attempt to swim for his life. He clung to a piece of the wreck momentarily but gave up his spot to a woman, who was eventually rescued. Despite the freezing temperatures of the water, Wyckoff was able to stay afloat until he found yet another piece of the severed boat. He floated until

he was sighted by a small craft. The icy waters robbed Wyckoff of the ability to speak or move. Once on shore, he was immediately taken to a house in Athens; he recovered and returned to New York City the very next day. Apparently, there were six members of the New York legislature on board *Swallow* the night it sank. Wyckoff said that when the boat struck the rocks, the "crash was dreadful."

The final outcome of a formal investigation deduced that the fog and snow had blocked the captain's vision, impairing his ability to navigate the river, and he lost his way in the channel.

Contrary reports revealed in the investigation that some believed that on the night that the *Swallow* left Albany for New York City with two other steamers, the ships' captains had made a wager to see which could make the quickest trip.

Prior to the fateful night, the *Swallow* steamed from Albany to New York on October 8, 1836, in eight hours and forty-two minutes, became the queen of the river and was advertised as the fastest steamboat in the world. Built in New York City and put in service in 1836 for the nighttime run between New York City and Albany, the *Swallow* had a wooden hull nearly as long as a football field and weighed 426 tons—it was a fast boat. The title of the world's fastest was also claimed by the *Rochester*. With two steamboats vying for the top spot, the two skippers organized a race on November 1. Thousands of dollars were wagered on the result of the two mighty ships facing off. Reports suggested that the boats were groomed like thoroughbreds, with extra weight discarded and the most flammable substances taken away. The *Rochester* successfully beat the *Swallow* that day, shaving almost twenty-two minutes off the record and rightfully earning the title of the fastest boat. A year later, the ships dueled on the river waters again, but this time, the *Swallow* took the prize. Despite a strong ebb tide, the *Swallow* made the trip in just under eight hours.

When the night of the *Swallow*'s fateful wreck was later revisited, many would say that the pilot, Captain A.H. Squires, was new to navigating the Hudson River, and when approaching Athens, he looked for the familiar beacon from the lighthouse known then as the Hudson City Light. Through the snow he saw a light, but instead of the beacon coming from the lighthouse, it was the light on the shore near where the postmaster lived. Not realizing his mistake soon enough, he turned the ship west, and the *Swallow* ran aground, split in two on a rock and then burst into flames.

The loss of the *Swallow* is considered one of Athens's greatest tragedies despite the fact that there was much money to be made the day after the wreck; many rowed sightseers out to the wreck for twenty-five cents a person.

The *Swallow* wasn't the only famous ship to run aground off Athens. Henry Hudson's ship, the *Halfmoon*, on a voyage of discovery, had similar trouble in 1609. Reports indicate that Hudson's ship ran aground on the Flats, and Hudson and his crew got off and feasted with the local Indians, making Athens possibly one of the first places in the New World where white men set their feet.

The mystery of the lost steamship is almost as perplexing as the house on Albany Avenue in nearby Valatie, New York, constructed from salvage of the wrecked riverboat by Mr. and Mrs. Walter Sterner. Ira Beckman claimed salvage rights on what was left of the wreck during the summer of 1846. He reportedly absconded with a treasure-trove of wood that he pulled from the ship's remains as it lay motionless on Noah's Brig. Beckman hauled what was left of the usable wooden planks more than seventeen miles from the Hudson River to Valatie to erect what is now known countywide as the Swallow House. The remaining wooden boards salvaged from the famous river steamer are now part of the vintage 1845 home featuring an elaborate staircase built in a corkscrew style. The stairs begin in the basement and spiral upward for two stories, with steps supported by a center pole.

Beckman didn't seem to own the house for long, as the deed shows that the Van Alstynes took ownership of the two-story home almost immediately after it was built. In the 1960s, when the home was owned by a Mr. Golden, the highway department considered destroying the house to change the route of the Post Road.

Eastfield

The Town that Never Was

Eastfield is the name of the unbelievable and authentically re-created early nineteenth-century American village in East Nassau, New York, in rural Rensselaer County. This amazing re-created colonial village was built by one man: Don Carpentier.

Don Carpentier, a professional potter, teacher, historian and preservationist, passed away, sadly, at his home at Eastfield in August 2014, at age sixty-two. A self-taught tinsmith, blacksmith, carpenter and mason, Don began collecting and reconstructing history from the years 1787–1840 when he was just a teenager in Knoxville, Tennessee, in the mid-1950s. In the 1960s, he moved with his parents to East Nassau, where he went to local schools and eventually graduated with a degree in historic preservation from Empire State College in 1972.

As many kids do, Don spent time in the woods of New York collecting old bottles and searching out buried treasures. Yet Don's curiosity for all things old went a step further. When he was just fifteen years old, he constructed a colonial A-frame building and, while still in high school, opened Chicken Coop Antiques, where he bought and sold a variety of items to finance his true love: historic preservation.

In 1971, Don's father gave him eight wooded acres near the east field of the Carpentier family farm. Don's first re-creation was an old blacksmith's shop, formerly a salvaged pigpen that he dismantled and trucked to the site.

Eastfield Village has now been on the map for over forty-five years and has some twenty extraordinary period buildings that were dismantled

and reassembled on the site, creating a charming village surrounding an authentic-looking village green.

It may be a coincidence or perhaps a clear case of reincarnation, but during his research of all things old, Don Carpentier discovered that he was a descendant of the Bissett and Price families. The Bissett family were stoneware potters in Old Bridge, New Jersey. Asher Bissett was a relatively unknown stoneware potter, an obscure name among collectors, yet Don felt he had a direct lineage to the artisan. He also professed a connection with Xerxes Price, a more noted stoneware potter who worked in Sayreville, New Jersey.

Don stumbled upon another strange fact when he discovered that Eastfield's mailing list revealed a person who lived on the former Bissett homestead in Old Bridge, where tons of wasters and kiln furniture were discovered on the property. Don was given some of this kiln and eventually found lost examples of the Bissetts' work, which he added to the Eastfield collection.

The magical detail of Don Carpentier's beloved village surrounds you the minute you drive off the smoothly paved country highway and traverse the curved and bumpy back road into deep woods until you are finally delivered on the steps of Eastfield's early American village. Mystical old maple trees loom along the edges of ancient woods, and a broken barn is the only landmark assuring you that you've found the entrance.

To imagine that Eastfield is similar to places like Sturbridge Village in Massachusetts or Old Austerlitz, in Austerlitz, New York, is doing it a grave disservice. Eastfield is extraordinarily different. For one, it is buried in a dense untouched forest, in a place that's so quiet that even small twigs snapping beside you can sound like a bigfoot is approaching. Because it's a village with no villagers, it's eerie and desolate, as if someone has mysteriously swiped all of the inhabitants of a once thriving town.

In perfectly preserved woodlands, with historic buildings all around, a peacefulness sweeps by, offering an opportunity to time travel.

Based solely on the size, structure and scale, it seems almost impossible that Eastfield Village has been completely re-created from abandoned buildings that were hauled to this out-of-the way place. There are currently twenty-eight different buildings on the site, including a 1793 tavern, an 1836 church, an 1811 general store and an 1834 doctor's office. Each, in its own way, is a perfect wonder.

Don Carpentier said in a video interview for MarthaStewart.com that as a kid he saw old buildings just like the ones he saved and preserved in his

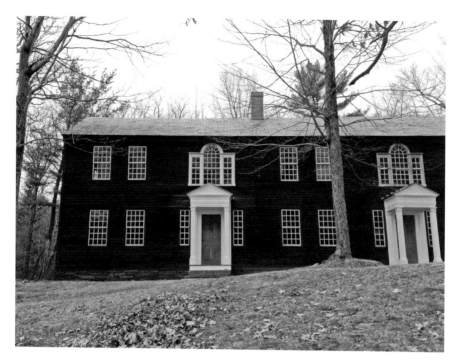

Eastfield Tavern. *Author photo.*

historic village, but they were being torn down or modernized and few were left. Like a boy at the puppy pound, Don had a deeply emotional reaction and desire to rescue history and use his land to create the small enclave so that he could rescue the buildings in their original condition. Yet seeing that dream through to fruition and relocating twenty-plus buildings to the site was no small feat.

Don was determined, almost possessed. He described how he would go out and find buildings (and often collect their contents) that were intact—but threatened with deterioration or ending up in a junk heap—and "bring them home." To do this, it was necessary to disassemble each structure and carefully catalogue each piece so that after transport, he and his helpers could put them back together exactly the way they were without changing a single thing.

The church had more than six thousand pieces that had to be reassembled, like a massive jigsaw puzzle. And what's even more remarkable is that for Don to be able to rebuild nineteenth-century buildings, he had to teach himself contemporary craftsmanship. The buildings are a whole lot more

Eastfield Church. *Author photo.*

than empty shells; they are filled with actual antiques or authentically restored items, and Don rebuilt them with original nineteenth-century tools.

The Briggs Tavern is the oldest building in the village insofar as it's the very first that Carpentier purchased (for just $500) and reconstructed, and through the project, he acquired the skills he needed to do restoration work.

In the process, he learned how to make and plane wooden moldings, plaster walls, paint and stencil. He learned how to forge metal parts in his blacksmith's shop, build fireplaces and construct masonry walls and foundations, as well as cut stone for the headstones in the graveyard.

Don Carpentier loved his project so much that he lived at Eastfield alone, forgoing modern conveniences like running water, heat and electric lights just so he could experience his reconstructed buildings. He was an immensely devoted man, though he thought people might think he was crazy to drag twenty buildings to his backyard and remake them.

Historic Eastfield Village offers a depth of history unmatched in the Hudson Valley. Walking on the cobblestones at Don Carpentier's strange Eastfield affords the opportunity to feel the roots of our region underneath you. Amid the post and beams, slate roofs, stone foundations and creaky oak floorboards is that palpable longing for things we have lost, or might have had it not been for one man's bizarre dream.

Throughout his life, Don Carpentier was obsessed, always building, always fixing; he felt his project would never be completed. He also wanted to make sure that Eastfield Village is not a museum. The rooms are dusty; the furniture is old, worn and feels lived-in, messy almost. There's a reason for that. Brown's 1811 General Store, the Clapper Tin Shop and the 1847 Gorton School House are all part of a living laboratory where those who take a workshop have the opportunity to intensely study and use tools typical of the late eighteenth and nineteenth centuries. He was deeply devoted to his work, right up until the end.

The founder of Eastfield Village, Don Carpentier, died at age sixty-two after a long battle with ALS. Since Don's death in 2014, the Historic Eastfield Foundation, a self-supporting organization run by a group of volunteers, has taken over responsibility for the village and continues to offer hands-on early American trades and historic preservation classes, workshops, lectures and symposia, annually conducted by experts from around the country.

The foundation's mission is to encourage crafts persons and train them in a variety of preservation skills. The group also produces publications and materials for the public and professionals. Learning is uniquely experiential in that participants practically live in the village and can use the actual artifacts to get a feel for how people worked in days gone by.

The village is open to visitors only one day a year, on Founders Day, in honor of Don Carpentier, the extraordinary man who built a town that never was.

20

Babes, Breweries and Albany's Ancient Ale

In New York's Hudson Valley, beer goes way back. Beer was introduced to New York by Europeans who traveled across the Atlantic. The Dutch had it on their ships in the 1600s, as it was a more reliable drink than water for crews at sea for months at a time.

In New Amsterdam, the Dutch built their first brewery in 1612.

Just north of New York City, in the agriculturally abundant lands of the Hudson Valley, brewing beer became popular quite quickly. For one, there were plenty of places to grow the grain needed for beer making, and the Hudson River provided a natural transportation system to ship the finished product to thirsty patrons south, in densely populated New York City. At that time, the breweries produced ale, and Albany ale was the best around.

It is not often discussed, but Albany is the oldest continuous settlement in the nation. The City of Albany still serves under its original charter, which dates to July 22, 1686, and has been the capital of New York State since 1797.

Early on, as settlements spread, brewing was done primarily at home, and home brewing recipes were confidential. As brewing was an integral part of Dutch society, many prominent Dutch families passed the recipes and the skill—as well as the wealth they accumulated from their breweries—through generations. The Dutch were savvy at keeping their breweries successful by negotiating with the Mohawk Indians, who protected their wheat and other crops and offered them safe trade passage routes.

Albany had another advantage, as it turned out to be a large supplier of grain, mostly wheat. The abundance of grain was used locally, and the surplus was sold to New York City and also exported by the Dutch to Holland. With so much wheat to be had, Albany expanded its home breweries into large public breweries. As they moved away from cottage industries into commercial industries, the brewers were taxed.

The first person to receive permission to sell beer in 1632 was Jacob Albertsen Planck. He was allowed to sell "to the men of the Company or to the savages" under Patroon Van Rensselaer. This was the beginning of licensed formal commercial breweries.

By the 1640s, brewing had become a significant business in Beverwijck (later named Albany). Competition for sales grew, and so did the fighting for territory. Laws were put into place for tap houses, such as no serving beer on the Sabbath and other restrictions. Despite the laws, brewers became wealthy, and with money comes power. The brewers quickly used their status to preserve their businesses and commercial interests. But then came the English.

When Dutch New Amsterdam became British New York in 1664, Beverwijck became Albany, named after Prince James, Duke of Albany. Albany's name was not the only thing that changed. The rules for brewing beer were also reestablished. Luckily, the English laws allowed the sale of beer to exist under a special Article of Transfer that was protected as a religious freedom.

As time went on, Albany became the largest brewing hub in the country, and Albany ale, as it was advertised, was on tap in all of the largest cities in the country until lager beer displaced it in popularity. Nevertheless, the brew masters of Albany had a reputation for making beer that rivaled beer in the Rhine and in English pubs where the science of beer making was a primary industry representing millions of dollars. In fact, in 1880–84, the total annual output of breweries in Albany was 332,794 barrels, valued at $2 million.

The history of the well-known brewers in Albany is a very long story. Some of the more recognizable names include Peter Ballantine (1791–1883), who was born in Dundee, Scotland, and, after immigrating to the United States in 1820, settled in Albany. In Albany, he learned to be a beer maker, and by 1830, Ballantine had founded the Ballantine Brewing company. About ten years later, Ballantine moved to Newark, New Jersey, to have better access to the New York City market. In New Jersey, he partnered with Erastus Patterson to lease General John R. Cumming's old High School Brewery,

which had been built in 1805. They operated as the Patterson & Ballantine Brewing Company.

The Albany Brewing Company was started by James Boyd, another Scot. Boyd was a knowledgeable brewer, and in 1796, he established the Arch Street Brewery, which later became the Albany Brewing Company, the area's first modern brewery.

Some ninety miles down the Hudson River from Albany, in Poughkeepsie, James Vassar ran a brewery with his son, John Guy. In 1811, the establishment was destroyed by a fire that also took the life of Vassar's son. To save his family from financial ruin, John Guy's younger brother, Matthew Vassar, opened a small brewery despite his distaste for the industry in general. Many years later, the same Matthew Vassar would put his brewery fortune to work to found the all-women's Vassar College.

With all the talk of brewers, brew masters and breweries and men and patroons, it makes sense to ask whether women ever played a role in the story of Hudson Valley beer. It is precisely this question that makes the story of beer in the Hudson region so very curious.

Hold on to your drink coasters everyone, because here's an interesting fact. Four thousand years before the birth of Christ, women brewers were making dozens of kinds of beer in Babylon and Sumeria. Perhaps the oldest narrative known to history, *The Epic of Gilgamesh*, contains references to Siduri—an archetypical "brewster" (the feminine word for brewer) and barmaid who gave beer, comfort and counsel to Gilgamesh, greatest of the Sumerian kings.

The earliest chemically confirmed barley beer to date was discovered at Godin Tepe, in the central Zagros Mountains of Iran, where fragments of a

Proto-cuneiform recording the allocation of beer, probably from southern Iraq, Late Prehistoric period, about 3100–3000 BC. *Wikimedia Commons.*

jug at least five thousand years old were found to be coated with beerstone, a residue byproduct of the brewing process.

Some of the earliest written evidence for beer production summoned a woman—to be precise, it was more like a goddess—to ensure that the magic of fermentation occurred. Ninkasi was the Sumerian goddess of beer. The "Hymn to Ninkasi" was a song praising her. The song was carved into an ancient cuneiform tablet in Sumeria around 1800 BCE, and it offers useful hints as to how beer was actually made at the time.

In 1992, archaeologists discovered chemical traces of beer in a jar fragment dating to the mid-fourth century BCE. At the same site, artifacts of early winemaking were found, leading archaeologists and others to believe that the idea of brewing beer possibly came originally from baking. One thought is that grains left out went through a fermentation process and inspired the creation of both wine and beer.

Back in the United States, Mary Lisle was the first known brewster in America and took over her father's Edinburgh Brewhouse in Philadelphia, which she operated until 1751.

What's more, women not only made beer, but they were also good at smuggling libations during Prohibition. According to the *Buffalo News*, in 1921, more than fifty thousand women were taking part in illegal bootlegging, which brutally frustrated lawmen. Apparently, women were far better at concealing booze than men. The women simply hid the bottles under their dresses and skirts. In fact, by the 1920s, women had devised creative fashions and devices to smuggle bottles, including "catcher's chest protector" type of container that held whiskey, and attached it to themselves.

Today in the Hudson Valley, women have both feet in the beer making industry. Crossroads Brewing Company, founded by Janine Bennett, is located in a historic 1893 opera house in Athens, New York, just across the river from the city of Hudson. Broken Bow Brewery is run by three women—Kathy LaMothe, Kasey LaMothe and Kristen Stone—and can be found in Tuckahoe, New York. The Hudson Valley even boasts its own Beer Trail, including both male- and female-owned pubs and breweries. The HVBT, by the way, was established by a woman. Bottoms up, everyone!

21

Insane Shaker Inventions

If you've ever met an inventor, you might think to yourself that they are a little bit strange. It's almost as if they're staring out into space and seeing something that you just can't see. Well, that's probably because they are.

Religions around the world have spoken of the notion of divine intervention, second sight and receiving the spirit. If ever there was a group that embodied these notions—this type of genius, if you will—it was the Shakers, a religious sect who made their spiritual home in New Lebanon, New York.

While inventing the clothespin might not seem particularly earth-shattering today, when the Shakers made this item for the first time in the 1800s, this little wooden gadget actually took the world by storm. This was also true for the more than one hundred or so other inventions the Shakers created and patents they held.

As a group, the Shakers, otherwise known as the United Society of Believers in Christ's Second Appearance, hold a unique place in Hudson Valley history. In 1774, they were led out of England's oppressive religious environs by a tiny little lady named Ann Lee. The four-foot-tall, pale and frail charismatic leader was on a mission, you could say, to extricate a small band of followers out of the punishing conditions of England, where food was scarce and work was very hard. Above all, Ann was motivated to move to follow her faith as a Shaker.

In England, Ann Lee had joined up with John and Jane Wardley, a married couple who branched off from the Quakers, also known as the

Society of Friends. In Quaker meetings, the members of the congregation were encouraged to receive the spirit, and often when they did, they were moved. The movement wasn't always internal, and often they would walk about the room, shake, sing and shout under the influence of the sensations of the "inner light that pulses through them," according to Butler and Sprigg's book, *Inner Light: The Shaker Legacy*. Shakers would sometimes appear like agitated storm clouds whisking past one another in the sky. What made Shakers so different from other religions was their belief that the Lord directly entered their souls. And so it made sense to the Wardleys' sect of Quakers that having a direct encounter with God could definitely cause bodily shaking.

The Wardleys left the Quaker religion feeling the influence of French prophets, the Camisards, who were inclined to preach that the world was entering the end of days, an impending millennium, when Christ would return to earth for a second time.

Both the Camisards and the Quakers were noted for accepting female ministry. Quaker women preached as often as men. So in 1774, it's not all that surprising to find a woman, Ann Lee, leading her spiritual followers to America.

Before leaving England, Ann had a mystical vision. While in prison for disturbing the peace, she lay half starved and exhausted on the floor of her cold cell. Ann had all but given up hope when she reported that she was visited by God. Ann said she received a direct message from her Lord telling her she was the female counterpart to Jesus; she was the incarnation of the

Group of Shakers. *Library of Congress.*

second coming of Christ. This extraordinary event convinced Ann and her followers to travel to America to build a utopian community to prepare for the end of the world.

Ann and her group of worshippers landed in New York in August 1774, and within a short time, Ann's husband, Abraham Standerin (sometimes called Stanley), abandoned her. By some reports, Abraham left Ann because she believed in the practice of celibacy as part of her spiritual devotion. Nevertheless, Ann persevered alone.

In 1776, while the American Revolution brewing in New York threatened an impending war with Britain, everything to do with England was a target of hatred. This included Ann and her small group of Shakers. Fearing persecution, they fled north of the city for Niskayuna (now Watervliet), which at the time was considered wilderness. A revivalist movement was taking hold there.

Like many pioneers attempting a life in the woods, Ann and her fellow Shakers needed to make everything themselves and endure tremendous and continual hard work, not to mention trying to live harmoniously with their new neighbors, the Mohawk Indians. Luckily for Ann and her troop, the Iroquois Nation, under which the Mohawks fell, shared some interesting similarities with the Shakers, and that helped relations.

The Iroquois Indians held women in great esteem, so they had no trouble honoring Ann Lee's claim of divinity. Ann's relationship with the Native Americans would become part of the foundation for Shaker inventions. Over time, the Native Americans taught the Shakers the benefits of indigenous herbal remedies, cultivation of native plants and traditional herbal medicine practices. They also taught the Shakers the craft of basketry.

The growing Shaker community settled on Mount Lebanon in New Lebanon, New York, making this their holy site and spiritual center. From on top of the mountain, the Shakers could view the entire wondrous New Lebanon Valley with its rich land for farming, clean water and fresh country air.

As with everything they did, the Shaker community was orderly and, above all, productive. They treated every action as a form of worship. Because the Shakers sheltered themselves away from society and rejected modern life to better focus on prayer, much of their day was spent performing useful tasks by making things. Here's one example of how they invented ingenious time-saving machines.

As the story goes, a Shaker sister known as Sarah Babbit, or Sister Tabitha, stood watching one of the brothers, or brethren, saw wood and noticed that

with a straight saw, half the motion was lost. In a flash, she envisioned how he could be far more productive, and the idea of the circular saw came to her. She tested her idea in secret by creating a small tin disk with notches on the edges and slipped it over the spool of her spinning wheel. Babbit tested it on a shingle and found that it worked quite well. Though at first the invention was quite crude, it was soon improved upon by George Wickersham, and the circular saw was born. Wickersham is also credited with inventing the very first turbine water wheel. And the list of inventions goes on.

Two brothers named Henry Bennett and Amos Bishop invented the very first threshing machine in 1811, and the planing machine was also invented around that same time at Mount Lebanon. (The screw propeller, rabbit metal, the revolving harrow, a sash balance, one-horse wagons and cut nails also topped the list of inventions.)

As the Shaker law demanded that members of the religious community stay clean (as well as orderly and healthy), it's not surprising to find out that the Shakers also invented the washing machine. The first was built in New Lebanon and later perfected by the Canterbury Shakers. The group actually received a patent for their machine in 1858. The Shakers' washer bore absolutely no resemblance to the kind we use in modern times. It looked more like a miniature car wash, with two large boxes standing side by side and wooden paddles near the floor. There was a drain in the floor as well where dirty, soapy water would pass out. Clean water flowed above through pipes powered by steam. It's important to know that Shaker communities sometimes had hundreds of members, which meant washing a lot of clothes, as well as linens and such, so this kind of institutional washer worked just fine for their purposes.

The washer created by the Shakers was so unique, in fact, it made the pages of *Scientific American*, a noted magazine of the time. Though the original machine would later go through other design changes to make it even smaller, it gained a second patent in 1877.

In the late 1800s, Shaker inventions like the washing machine made the news quite often. The papers of the day reported that Shaker dwellings at New Lebanon had a

mammoth cradle or mill where the clothes were effectively cleansed. This mill was invented and largely constructed by one of the brothers years ago. It is run by a water power motor. The clothes are put in hireling with heavy wooden balls. The motor then rocks the cradle violently backward and forward and the pounding at the balls take the dirt all out. From the cradle the clothes are

put in the wringer. It is not a wringer, but a substitute for one, the water being taken from the clothes by the pressure of the air. This wringer is also run by the motor. Then, instead of lugging big basketfuls of wet clothes out to the line, they are put into a sort of wooden box on a little cart and drawn out. The lines are of galvanized iron strung across a frame work of iron piping. The turf is close and fine and here may be found occasionally white goods spread out to bleach, or rye straws drying to be woven into Shaker bonnets.

To further solve their desire for clean, fresh clothing and linens, Shakers were wise in constructing drying and ironing rooms on upper floors of their homes, where the heat flowed most efficiently. These upper levels were also used for drying herbs and fruit in barrels and boxes.

According to a Historic American Landscape Survey, the motor power for the washer was furnished by water coming from "a beautiful reservoir on the hill above the village, and in addition, there was a 400-foot well up on the hill and there's mountain water, so-called, coming from springs. With this supply, the Shakers can afford to be reckless in their use of water. The natural pressure is so great that a stream from one of the hydrants scattered over the grounds can be sent over the five-story dwelling house. There are numerous bathrooms in the different buildings."

If the preceding list isn't thoroughly astonishing, Shaker genius Theodore Bates of Mount Lebanon also invented the first flatiron broom, and the machinery for turning the wood for the broom handles was created by Jesse Welds.

Though this may be hard to believe, the very first metal pens were created by Shaker brother Isaac Newton Young, a fabulous and renowned clockmaker. These early pens were originally made of brass and silver in the year 1819. One of the Shakers' lesser-known inventions is an item called the stereoscopy.

Probably one of the items Shakers are most known for are seeds. They were among the very first to grow, package and market their medicinal herbs and extracts. In the *Oswego Daily Times* of Wednesday, March 6, 1895, the Shakers' famous digestive cordial was described in this way:

It is prepared from roots and herbs cultivated solely by them. Nothing more certain, safe and palatable can be imagined. It expels the impurities from the body by means of the bowels, kidneys and skin, imparts vigor and tone to the stomach upon whose proper action all our strength, activity and endurance depend.

Lebanon Sycamore Tree/Healing Spring. *Courtesy of the New Lebanon Historical Society.*

The cure cost only ten cents, and its immediate effect was guaranteed because, as the writer confirms, the Shakers' "high reputation for skill as herbalists, for honesty and religious sincerity guarantees whatever they recommend." Dedicated to the health of their own community and delivering fine cures, the Shaker herb business was enormous. "It's possible that the Shakers were first to develop a means of manufacturing medicines in pill form with a wooden pill maker," said author Steven Miller in his book *Inspired Innovations: A Celebration of Shaker Ingenuity*. One of these devices was acquired in New Lebanon in the 1930s.

The Shakers also made a very early version of the wheelchair by taking one of their homemade chairs and fitting it with wheels to make it mobile. The list of Shaker ideas from the New Lebanon community included the three-legged cane and the very first walker, made of wood. The Shakers used "adult cradles" for elders in their final days. In a catalogue called *Products of Intelligence*, the New Lebanon Shakers showed the very first chamois eyeglass cleaners. They created beds where the head or foot could be raised, and the list goes on.

The insane inventions of the Shakers of Mount Lebanon had roots in the region, and perhaps the very water that ran off the mountain to a sacred swamp below had something to do with their ingenuity. That story is for another day.

22

The Poughkeepsie Seer

Tell me not in mournful numbers,
"Life is but an empty dream!"
For the soul is dead that slumbers,
And things are not what they seem.
—*A.J. Davis*

Andrew Jackson Davis was widely known in the mid-1800s as an American spiritualist and one of three or four great leaders of the spiritualist movement in our country. He has been called a high priest, a preacher and the Seer of Poughkeepsie.

A *seer* is often defined as a clairvoyant who is able to enter into a higher state of consciousness, or trance state, and access information otherwise unavailable to humans.

As a spirit medium, Davis wrote and lectured and produced over thirty books he reportedly received from spirit communicators. His special gift, it was said, was his ability to diagnose diseases by clairvoyant means, an ability on par with such notable supernatural healers as Edgar Cayce. Remarkably, it wasn't until Andrew Jackson Davis turned sixty years old that he actually obtained a medical degree from the Medical College in New York and became a practicing doctor in Boston. His method for diagnosing was simply to put his fingertips lightly on the palm of the patient's hand.

He was born in Blooming Grove, Orange County, New York—a tiny hamlet along the Hudson River—on August 11, 1826. Davis received little

or no education growing up in the wretchedly poor farming community. The Davis family moved about in a "traveling wagon," hoping to find better conditions and more work. On their way through Hudson Valley towns, wrote Davis, the family experienced "a thousand and one little hardships and shipwrecks."

They eventually moved from Blooming Grove to Staatsburgh, not far from Rhinebeck. To say they were poor is truly not enough to describe the desperate situation they endured. Davis wrote, "But the fact was that there could not be found in that tenement a bit of bread of any description, nor any substance resembling a vegetable, except a few decayed turnips in the attic chamber." To avoid starving, Davis's family moved again, this time to Hyde Park, where his father was hired by the landlord to do fieldwork. He said that his family members found themselves "painfully embarrassed" by their poverty and ignorance.

Growing up, Davis became unexplainably open to alternative ideas, and as a boy, he found a personal pathway to his own spiritual powers as a clairvoyant. These powers may have already been in his breeding.

Andrew Jackson Davis was particularly attached to his mother, Elizabeth, and the two shared a secret devotion to the ways of "providence." Davis's mother was also deeply superstitious. She spoke often of bad dreams, telling signs and strange omens. Davis believed his mother had been blessed with real clairvoyance, which he called "real spirit intercourse."

Yet despite his devotion to her, under his mother's unsteady supervision, Davis nearly died several times. The first occasion was due to a horrible riding accident. On another occasion, he became near fatally sick and extremely weak from malnutrition and some undiagnosed disease. Because his mother persistently believed that bad things would happen, often they did.

At age eleven, Davis went to school in Hyde Park. His achievements, however, were few. Under his teacher, Mr. DeWitt, he said he learned to spell words of two syllables. His penmanship, however, was "remote and indefinite." Young Davis also failed miserably at recalling dates and names, and he could not pass his map lessons, of which he said the words appeared like a mess and were "too hard to be spelled or spoken."

From his days as a young boy, Davis used to go into strange trances, during which he claimed to receive remarkable "revelations." But the first real sign of his mysterious clairvoyance came when he cured himself of an illness. While he was suffering from a raging virus, Davis reportedly heard a voice tell him to "drink the sap of a sugar-maple." The voices visited him again one day while he was working on a local cow farm. He said he heard "a

mysterious melody, these words: 'You may desire to travel.'" The next time he heard the celestial sounds, he said it whispered, "To Poughkeepsie."

Convincing his family to move in early autumn of 1839, he and his father walked to Poughkeepsie, where his father found steady employment in a manufacturing company. Davis would, from that point on, refer to Poughkeepsie as his "native village."

Soon after the move in 1841, after returning home, he opened the back gate of the family yard and reported "a black veil suddenly dropped over my face. All space seemed to be filled with a golden radiance." A voice followed soon after. It was his mother's. She whispered, "Come here child, I want to show you my new house." Minutes later, in a blinding trance, he said he gained access to "the gilded door of my mother's high and holy home." It was then that Davis said he was guided to what seemed like a glittering palace, only to find himself at the end of a glorious hallway and witness his mother dying.

It was the lectures he heard on animal magnetism and hypnotism in Poughkeepsie in 1843 that truly changed his life. At age seventeen, Davis attended a lecture by Dr. J.S. Grimes, a phrenologist and mesmerist visiting Poughkeepsie. Though at the lecture he failed to be mesmerized, he arrived at his neighbor's house, Mr. Levingston, later that day and was put under a sort of hypnotic trance. The trance allowed his clairvoyant powers to truly come alive—so much so that he began to "see through his forehead."

Davis's uncanny access to great volumes of knowledge seemed to have been bestowed upon him by way of "human magnetism," whereby he received wisdom directly from the universe, rather than from mere books. He gained this access by entering what Davis called a "superior state." His abilities were so strong, he said he could recall life before he was born—before he "awakened into conscious memory."

Amazingly, Davis was able to recount scenes that took place around him on the very day he was born, when he was just a newborn baby. He said, "When the soul makes its first record of memory, it then merges from the mystic vale of babyhood into a definite and self-conscious being." Jackson was also one of the rare people on the earth born with a veil over his face, otherwise called a "caul." A person born with a caul was believed to have psychic powers: for example, the ability to see spirits and see into the future.

Davis's abilities in the supernatural were so refined, in fact, that he said recalled the exact conversation that took place on the day his father gave him his name. "I'm going to vote for Old Hickory," his father said, "the hero of New Orleans—the greatest man a-livin in the world; and I want this ere boy to bear that ere great man's name—Andrew Jackson!"

Andrew Jackson Davis didn't hide behind any magic curtain, nor did he shield the public from the ways in which he performed his clairvoyant healing. Mr. Davis plainly revealed in his autobiography the secret of his extraordinary gifts. Davis also spells out his belief in regard to the meaning of all human life. He explained it simply: "The beginning and end of all human endeavor is to *Exist*."

On January 1, 1844, Davis described having an unusual visionary experience. He called it his psychic "flight through space," where he was "born again, in the spirit." His vision, which resembled a modern-day out-of-body experience, allowed him access to a new world. He said, "It seemed that the whole earth, with all its inhabitants, had suddenly translated into some Elysium." Elysium has been described as a state of the dead and a state of perfect happiness.

On his fantastic journey, Davis said he met the ancient Greek physical named Galen (circa AD 129–199) and the eighteenth-century Swedish visionary spiritual philosopher Emanuel Swedenborg (1688–1772). Galen gave Davis a magical staff of healing, while Swedenborg promised to stay by his side, provide instruction and guide him on his spiritualist path.

The psychic flight described by Davis sent him speeding at an incredible velocity over the Catskill Mountains and across the Hudson River. Traveling in a strange trance state, Davis woke up the next day actually in the Catskill Mountains, forty miles from where he started in Poughkeepsie.

Soon after this experience, he began to follow the emerging spiritualism moment. Spiritualism at the time was described as the act of living people talking to the dead. Davis became an active and vocal advocate. He said in addressing an audience in 1852 at a Spirit Rappers Convention in Worcester, Massachusetts, that spiritualism "is a new power, which is to regenerate society and dispel error and sin, and make this world's heaven below."

After many years of working as a healer, Davis turned to writing. At age twenty, he produced a book, *Nature's Divine Revelations*, which was considered amazing given Davis's lack of education. Clearly, Davis was under the influence of some divine intelligence, led by unseen guardians that gave him this uncanny ability. The book became somewhat of a bible for the spiritualist movement.

From 1850 to 1855, Davis wrote his major work and spiritualist book called *The Great Harmonia*, in five volumes. Beyond the general spiritualist circles of believers, *The Great Harmonia* was amazingly influential. In much of the nineteenth century, while American radical religious, social, educational and medical thought was shifting and moving away from

traditional ways, Davis preached that the spiritual realm was continuous with nature and governed by its own natural laws. He believed that after a person's physical death, spirits progressed through a series of six spheres above the earth to greater and greater degrees of perfection until they reached "Summerland" or paradise, which, at the time, was good news for nineteenth-century radical thinkers.

Davis's unusual abilities were not accepted by everyone, but despite the criticism, his autobiography, *The Magic Staff*, states that "perhaps thousands regarded Mr. Davis as a person of almost supernatural abilities," and that the book is "a precedented record, entirely authentic, and beyond refutation." His wife, Mary, was his greatest supporter. She wrote that in spite of the fact that Davis was often under "discouraging conditions," he reached what she said was a "state of beautiful existence."

Bibliography

Books

Bauer, Cheryl. *The Shakers of Union Village*. Charleston, SC: Arcadia Publishing, 2007.

Bishop, John Leander, Edwin Troxell Freedley and Edward Young. *A History of American Manufactures from 1608 to 1860*. Philadelphia: E Young, 1861.

Brockett, M.D. *Men of Our Day or Biographical Sketches of Patriots, Orators, Statesmen, Generals, Reformers, Financiers, and Merchants*. Philadelphia: Zeigler, McCurdy, 1868.

Brook, Henry. *True Stories of Gangsters: Usborne True Stories*. London: Usborne Publishing, 2004.

Cozzens, Issachar. *The Geological History of Manhattan or New York Island*. New York: W.E. Dean, 1843.

Cramer, Carl. *The Screaming Ghost and Other Stories*. New York: Alfred A. Knopf, 1956.

Crowley, Aleister. *Confessions of Aleister Crowley: An Autohagiography*. New York: Penguin Reprint Edition, 1989.

Cutter, William Richard. *Genealogical and Family History of New York*. New York: Lewis Historical Publishing, 1910.

Davis, Andrew Jackson. *The Magic Staff: An Autobiography of Andrew Jackson Davis*. New York: J.S. Brown & Company, 1857.

Deluca, Dan. *The Old Leather Man: Historical Accounts of a Connecticut and New York Legend*. Middletown, CT: Wesleyan University Press, 2013.

Gravina, Craig, and Alan McLeod. *Upper Hudson Valley Beer*. Charleston, SC: The History Press, 2014.

Guiley, Rosemary. *The Encyclopedia of Witches, Witchcraft and Wicca*. New York: Facts on File, 2008.

Hall, Oakley, III. *Jarry and Me: The Autobiography of Alfred Jarry*. San Francisco: Absintheur Press, 2010.

The Harmonial Philosophy: A Compendium and Digest of the Works of Andrew Jackson Davis. London: Rider and Son, 1917.

Hartnagel, Chris Andrew, and Sherman Chauncey Bishop. *The Mastodons, Mammoths and Other Pleistocene Mammals of New York State*. Charleston, SC: Nabu Press, 2011.

Hazelton Haight, Elizabeth, ed. *The Life of Matthew Vassar*. Oxford, UK: Oxford University Press, 1916.

Johnston, Johanna. *Mrs. Satan: The Incredible Saga of Victoria C. Woodhull*. New York: Popular Library, 1967.

Lossing, Benson J. *Vassar College and Its Founder*. New York: C.A. Alvord, 1867.

Maxson, Thomas F. *Mount Ninham: The Ridge of Patriots*. Kent, NY: Rangerville Press, 2009.

Miller, Steven. *Inspired Innovations: A Celebration of Shaker Ingenuity*. Hanover, NH: University Press of New England, 2010.

Oliver, Garrett, ed. *The Oxford Companion to Beer*. Oxford, UK: Oxford University Press, 2011.

Oshinsky, David M. *Polio: An American Story*. Oxford, UK: Oxford University Press, 2006.

Reeder, Colonel Red. *The West Point Story*. New York: Random House, 1970.

Roosevelt, Eleanor. *Autobiography of Eleanor Roosevelt*. Reprint, Boston: Da Capo Press, 2000.

Semonin, Paul. *American Monster: How the Nation's First Prehistoric Creature Became a Symbol of National Identity*. New York: New York University Press, 2000.

Skinner, Charles M. *Myths and Legends of Our Own Land*. Charleston, SC: BiblioBazaar, 2008.

Thomson, Keith Stewart. *The Legacy of the Mastodon: The Golden Age of Fossils in America*. New Haven, CT: Yale University Press, 2009.

Tighe, Mary Ann, and Elizabeth E. Lang. *Art America*. New York: McGraw-Hill Book Company, 1977.

Tilton, Theodore. *Victoria C. Woodhull, A Biographical Sketch*. New York: Golden Age, 1871.

Tuchinsky, Adam. *Horace Greeley's New York Tribune*. Ithaca, NY: Cornell University Press, 2009.

Wiesen Cook, Blanche. *Eleanor Roosevelt*. Vol. 1, *The Early Years, 1884–1933*. New York: Viking, 1992.

Articles

Albany Times Union. "Anniversary of Tragedy of Hudson River." March 27, 1926.

Alexander, Gary. "Crowley in the Valley." http://users.bestweb.net/~kali93/esopus.htm.

Barnes, Steve. "Oakley Hall, Now and Then." *Albany Times Union,* January 7, 2010. http://blog.timesunion.com/localarts/oakley-hall-now-and-then/3956/2010.

Barry, John W. "Eleanor Roosevelt, Gun Owner." *Poughkeepsie Journal,* July 12, 2015.

Binghamton Press. "Letchworth Village to End Feeblemindedness. 2000-Acre Institution for the Cure of the State's Idiots to be Formally Opened June 1, 1911." May 9, 1911.

Brooklyn Standard Union. "Says Other States Send Defective Children Here." April 19, 1922.

Catskill Recorder. "His Ancestry Is Historic." March 21, 1930.

Chatham Courier. "The Swallow House." March 30, 1961.

Columbia Republican. "A New Elder: Levi Shaw No Longer Leader of the Shakers." February 3, 1903.

Cook, Thaddeus, and Barbara Doyle. "Stone Chambers of Putnam Valley." *Hudson Valley Review* 7, no. 2 (September 1990): 77.

Corcoran, David. "Theill's Journal; Graves Without Names for the Forgotten Mentally Retarded." *New York Times,* December 9, 1991.

Daily Register. "Shaker Saving Labor." July 23, 1898.

Dillon, Wes. "James D. Julia's October 2014 Fine Firearms Auction to Feature a Remarkable Outdoorsman Revolver Owned and Used by Former First Lady Eleanor Roosevelt." *PrWeb,* March 9, 2017. http://www.prweb.com/releases/prweb12187192.htm.

East Hampton Star. "If James Cagney and Eleanor Roosevelt Were Alive Today and Attended a Black Tie Dinner in the Big Apple, Mayor Koch Would Have Them Arrested!" June 11, 1987.

Evening Gazette (Rhinebeck, NY). "The Forest at Our Door." October 11, 1870.

Evening Post. "Call of the Catskills." May 18, 1907.

Feineman, Carol. "Documentary Chronicles Playwright's Recovery." *Union,* April 30, 2002. http://www.theunion.com/news/local-news/documentary-chronicles-playwrights-recovery.

Hawkins, AWR. "First Lady Eleanor Roosevelt: 'I Carry a Pistol, and I'm a Fairly Good Shot.'" *Ammoland,* October 21, 2014. http://www.ammoland.com/2014/10/first-lady-eleanor-roosevelt-i-carry-a-pistol-and-im-a-fairly-good-shot/#ixzz4XCqKS6Jt.

Henry, Derrick. "A Hike Among the Ruins." *New York Times*, September 24, 2008.

Herald & Torch Light. "Narrative of Lucy Ann Lobdell, the Female Hunter of Delaware and Sullivan Counties, N.Y." 1855.

———. "A Strange Story." September 13, 1871. http://www.oneonta.edu/library/archive/dailylife/family/1871lucygalr.html.

Ithaca Daily News. "Colored Line at Vassar." August 17, 1897.

Keiter, Jane. "Deborah Sampson, Continental Soldier: The Westchester Connection." *Winchester Historian* 76, no. 1 (Winter 2000).

Kingston Daily Freeman. "Hotel Kaaterskill Ends Career in Pillar of Fire." September 9, 1924.

Kirsch, Tom. "Bennett School for Girls." http://opacity.us/site11_bennett_school_for_girls.htm.

Lara, Adair. "Oakley Hall Is the Most Famous Writer You Never Heard Of." *California Magazine*, February 2009. https://alumni.berkeley.edu/california-magazine/january-february-2009-effect-change/writers-guide.

Mark, Joshua J. "Hymn to Ninkasi, Goddess of Beer." *Ancient History Encyclopedia*, March 1, 2001. http://www.ancient.eu/article/222.

Martin, John H. "Saints, Sinners and Reformers: The Burned Over District Revisited." *Crooked Lake Review*, Fall 2005. http://www.crookedlakereview.com/articles/136_150/137fall2005/137martin.html.

New Haven Register. "The Old Leather Man." December 11, 1888.

New York Evening Post. "Doodletown Is Nervous." February 13, 1909.

———. "Lehman Lauds State Hospitals. 'Have Become Models Throughout World,' He Says at Letchworth Village." June 14, 1933.

New York Herald. "Daily Craft Will Fly from New York City to Interstate Park." May 31, 1919.

New York Sun. "Famous Spiritualist Dead." January 14, 1910.

New York World. "Fate of a Child. The Romance of the Slater Family—Mother and Daughter." February 14, 1873.

Nolan Neil, Helen. "The Governor's Former Body Guard, Earl. R. Miller, Sued by Wife Ponders Future." *Albany Sunday Times Union*, August 22, 1948.

Nurin, Tara. "How Women Brewsters Saved the World." *Beer & Brewing Magazine*, April 21, 2016. https://beerandbrewing.com/VNN4oCYAAGdLRZ-I/article/how-women-brewsters-saved-the-world.

Peekskill Highland Democrat. "The Leather Man Frightened Children." December 7, 1928.

"A Place at the Table." *Vassar Quarterly* 107, no. 1 (Winter 2011). https://vq.vassar.edu/issues/2011/01/web-features/a-place-at-the-table.html.

Port Chester Journal. "The Old Leather Man." January 31, 1889.

Postscripts. "State Prison or State Park? Preserving the Hudson's Far Shore." April 20, 2010. http://notorc.blogspot.com/2010/04/state-prison-or-state-park-preserving.html.

Putnam County Courier. "UFO Believers Will Discuss Strange Lights in Putnam." August 15, 1984.

Roosevelt, Eleanor. "My Day: March 8–14." https://fdrlibrary.wordpress.com/2010/03/08/eleanor-roosevelt-my-day-march-8-14.

Schmaltz, Jeffrey. "Strange Sights Brighten the Night Skies Upstate." *New York Times*, August 24, 1984.

Schreck, Tom. "Westchester Ties to the Wizard of Oz and UFOs. Answering the County's Weirdest Curiosities." *Westchester Magazine*, November 29, 2013. http://www.westchestermagazine.com/Westchester-Magazine/December-2013/The-Countys-Ties-to-the-Wizard-of-Oz-and-UFOs.

Seeman, Erik R. "Native Spirits, Shaker Visions: Speaking with the Dead in the Early Republic." *Journal of the Early Republic* 35, no. 3 (Fall 2015): 347–73.

Semolina, Paul. "Peal's Mastodon: A Skeleton in Our Closet." *Common-Place* 4, no. 2 (January 2004). http://common-place.org/book/peales-mastodon-the-skeleton-in-our-closet.

Smith, Roberta. "Mercedes Matter, 87, Art and Studio School Founder." *New York Times*. December 7, 2001.

Tompkins, Louise. "Halcyon Hall Was Filled with Music at Its Grand Opening." *Millbrook Roundtable*, September 1983.

Tri-State Union. "A Winter's Flood." December 13, 1878.

Troy Daily Whig. "The Late Disaster." April 10, 1845.

Vieira, Jim. "Search for the Mysterious Stone Builders of New England." Northeast Antiquities Research Association. http://www.barbaradelong.com/special-projects/secrets-of-the-stones/search-for-the-mysterious-stone-builders-of-new-england-2.

Waddell, G.L. "When Deborah Went to War." *National Republic*, July 26, 1932. http://web2.toledolibrary.org/images/docwidget/Mss-Coll_318_Owen_Washington/Mss_Coll_318_Owen_Washington.pdf.

York, Michelle. "What's in a Name? Some Obscure Scholarships Often Go Begging." *New York Times*, January 3, 2006.

Websites

"About Shaker Baskets and Basketry." http://www.simplybaskets.com/ShakerBasketryInformation.html.

Aleister Crowley Biography. http://www.thefamouspeople.com/profiles/frater-perdurabo-644.php#ib61JEAiAZXXreBr.99.

"Catskill Mountain Tourism and Lexington Resorts." https://www.facebook.com/pg/TheWeatherDork/photos/?tab=album&album_id=512100598800422.

Flad, Harvey K. "The History of Earth Science and Geography at Vassar College." https://earthscienceandgeography.vassar.edu/about/history.html.

Hancock Shaker Village. "A Brief History." http://hancockshakervillage.org/shakers/history.

"Historic Albany County." http://www.albanycounty.com/about/historicalbanycounty.aspx.

"History of Sullivan County." http://genealogytrails.com/ny/sullivan/history_neversink.html.

"History of the Horace Greeley House." http://www.newcastlehs.org/historic-new-castle/history-of-the-horace-greeley-house.

"History of the New York City Water Supply." http://www.cwconline.org/history_of_the_nyc_water_supply.html.

"History of Women Brewers." https://brewess.wordpress.com/2010/04/30/history-of-women-brewers.

Kreisberg, Glenn. "Serpent of the North: Overlook Mountain Draco Correlation." *Graham Hancock*, last modified December 20, 2010. https://grahamhancock.com/kreisbergg5.

"Mysterious Ancient Stone Chambers and Unexplained Energy Force in the Ninham Mountain, Putnam County." http://www.messagetoeagle.com/mysterious-ancient-stone-chambers-and-unexplained-energy-force-in-the-ninham-mou.ntain-putnam-county.

Park, T. Peter. "The Poughkeepsie Seer." The Anomalist. http://www.anomalist.com/features/seer.html.

Stefanidakis, Revered Simeon. "Forerunners to Modern Spiritualism: Andrew Jackson Davis (1826–1910)." First Spiritual Temple. http://www.fst.org/spirit3.htm.

Vassar College. www.vassar.edu.

Zipp, Brandt. "Don Carpentier, 1951–2014." *Crocker Farm*, last modified August 28, 2014. http://www.crockerfarm.com/blog/2014/08/don-carpentier-1951-2014.

Miscellaneous

Du Bois, Patterson. *The Mountaineer of the Neversink: A Poem in Four Cantos.* Philadelphia: H.B. Ashmead, 1873.

Kiessling, Elmer C. "Watertown Remembered." Report to the Watertown Historical Society, 1978.

Octagon Houses Collection, 1940–1979. New York State Historical Association Research Library. http://www.fenimoreartmuseum.org/library/special_collections/?page_id=422.

"Reconnaissance Level Historic Resources Survey: Town of Lexington, Greene County, NY." December 1, 2015. Conducted by the Town of Lexington, NY, prepared by Jesse Ravage, Preservation Consultant. http://www.lexingtonny.com/uploads/3/4/3/9/34399421/historic_resources_survey_pg_18_to_38.pdf.

About the Author

Allison is a graduate of Fordham University in New York City with a degree in communications and creative writing. She spent much of her professional career in public relations in New York and has traveled throughout the world promoting health and fitness resorts. In her work as a writer, Allison has written plays and movie reviews, as well as short fiction, articles, and essays on local people, places, and history in her adopted home of Columbia County, New York.

She is a writer at heart and has history in her genes. Her family on her father's side has kept meticulous records of the Guertins dating back to the early 1600s in Anjou, France.

The idea of writing local histories blossomed when she and her significant other, Adam, purchased a historic 1740s colonial home in the village of Malden Bridge in the town of Chatham. She and Adam have lived there happily for over twenty years with their two cats and possibly several other previous inhabitants.

Hudson Valley Curiosities, Allison's second history book, features many of the stories she discovered while researching *Hidden History of Columbia County, New York* (The History Press, 2014). It contains some of the Hudson Valley's most suspenseful stories and features some of the most famous and infamous people to step foot in the region.